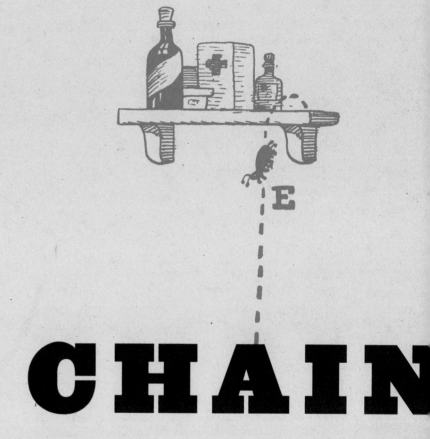

E

CHAIN

REACTION

RUBE GOLDBERG AND CONTEMPORARY ART

IAN BERRY

WITH A FLIP BOOK BY **DEAN SNYDER** AND POEM BY **LAWRENCE RAAB**

WILLIAMS COLLEGE MUSEUM OF ART

THE TANG TEACHING MUSEUM AND ART GALLERY AT SKIDMORE COLLEGE

CHAIN REACTION:

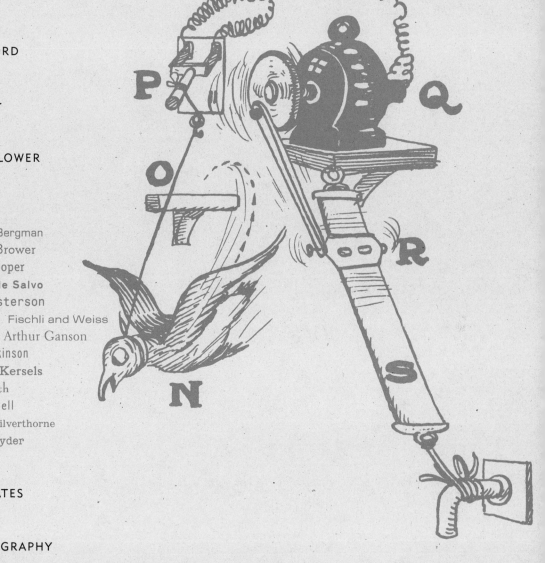

A DIALOGUE

"If, as you glance through these pages,
a smile flits across your face, a base-hit
will be registered on my subconscious
scoreboard of satisfaction."

—FROM *CHASING THE BLUES* BY RUBE GOLDBERG, 1912

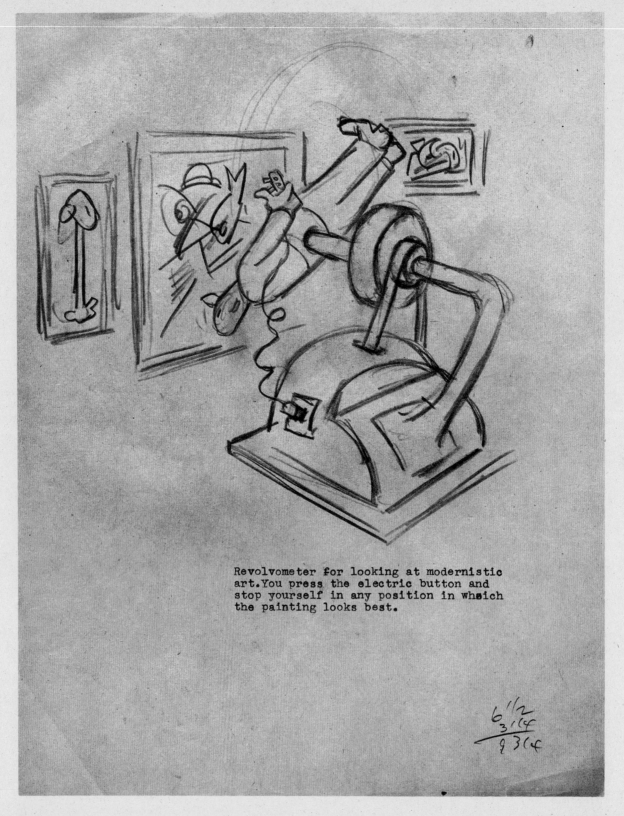

Revolvometer for looking at modernistic art. You press the electric button and stop yourself in any position in whaich the painting looks best.

Rube Goldberg
Revolvometer for looking at modernistic art, ca. 1960
Pencil and type on paper
11 x 8.5 inches

In honor of the 75th anniversary of the Williams College Museum of Art, and the first anniversary of The Tang Teaching Museum at Skidmore College, this publication celebrates both tradition and innovation. Past and present are juxtaposed with drawings by Rube Goldberg from the first half of the twentieth century and the work of thirteen contemporary artists. This publication also marks the first collaboration between these two distinguished institutions as co-organizers of the exhibition—*Chain Reaction: Rube Goldberg and Contemporary Art*.

This project began at Williams with then assistant curator Ian Berry, who now serves as the first curator of the Tang Museum. *Chain Reaction: Rube Goldberg and Contemporary Art* features fifty-six drawings from the Williams College Museum of Art's extensive collection of original Rube Goldberg material. Given to the museum by Rube's son George W. George (Williams, Class of 1941), the collection includes finished cartoons and preparatory sketches spanning the artist's prolific career.

Highlighted in the exhibition are works relating to the contraptions for which Rube is best known. Inventions that purport to make life easier and in fact prove infinitely more complicated, Rube's machines are equal parts cutting social criticism and hilarious, fantastic creation. The contemporary artists represent a diverse range of media and expose a direction in new art that is engaged with issues of mechanical and bodily interfaces.

As many of our colleagues know, the collaborative organization of an exhibition between two museums can often appear as if Rube Goldberg himself were in charge. At the Williams College Museum of Art and The Tang Teaching Museum this was clearly not the case. This collaboration has indeed led us to other 'chain reactions' and future projects that combine our students, faculty and curators to investigate topical ideas and engaging artists.

We are both grateful to the participating artists, the Estate of Rube Goldberg and his family, his biographer Maynard Frank Wolfe, as well as our respective staff members, for the part they have all played in contributing to the success and infectious spirit of this project. Lastly, we want to thank the National Endowment for the Arts for their generous support of the exhibition and to the many individual supporters of both our institutions.

Linda Shearer
DIRECTOR
WILLIAMS COLLEGE
MUSEUM OF ART

Charles Ashley Stainback
DAYTON DIRECTOR
THE TANG TEACHING MUSEUM
AND ART GALLERY
AT SKIDMORE COLLEGE

8 Rube Goldberg
Sketch for a cartoon, ca. 1960
Pencil on paper
11 x 8.5 inches

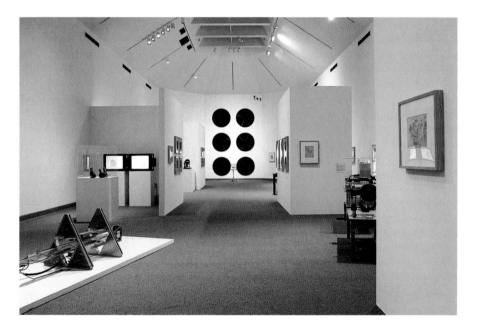

On this page begins *Tenigo*, a special project made for *Chain Reaction* by artist Dean Snyder. You are invited to start *Tenigo* by flipping the catalogue from back to front revealing the brief courtship and abrupt demise of its two fantastic main characters.

TOP: Installation view, Tang Museum

ABOVE: Installation view, Williams College Museum of Art

PROFESSOR BUTTS STROLLS BETWEEN TWO SETS OF GANGSTERS HAVING A MACHINE-GUN BATTLE AND IS STRUCK BY AN IDEA FOR KEEPING A BUTTON-HOLE FLOWER FRESH.

BREEZE (**A**) REVOLVES PINWHEEL (**B**) AND WINDS CORD (**C**) WHICH PULLS TRIGGER (**D**), RELEASING STRING (**E**) AND SHOOTING ARROW (**F**) AGAINST BUTTON (**G**) OF CIGAR-LIGHTER (**H**). HEAT FROM FLAME (**I**), RISING THROUGH FLUE (**J**), CAUSES ICE (**K**) TO MELT INTO PAN (**L**) AND DRIP INTO SMALL DERBY HAT (**M**). EXTRA WEIGHT PULLS CORD (**N**) WHICH MOVES ARROW (**O**), DIRECTING ATTENTION OF BABY SEAL (**P**) TO BASIN OF WATER (**Q**). SEAL DIVES IN, SPLASHING WATER INTO TROUGH (**R**). IT RUNS ON FLOWER (**S**) KEEPING IT FRESH.

IF THERE IS NO BREEZE TO START THE PINWHEEL, SNEAK UP BEHIND A BRIDE AND STEAL A FRESH FLOWER.

10 Rube Goldberg
Professor Butts strolls between
two sets of gangsters having a
machine gun battle and is
struck by an idea for keeping a
button-hole flower fresh, ca. 1930
Pen and ink on cardboard
8 x 18.75 inches

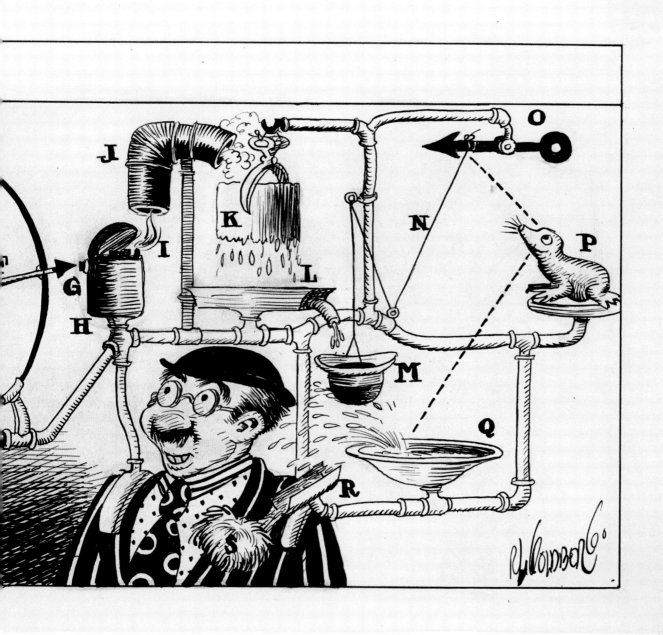

LAWRENCE RAAB RUBE GOLDBERG'S FLOWER

On a certain day you find yourself
walking down a street in a neighborhood
where every kind of misfortune is possible:
gaping manholes, grand pianos
tumbling from high buildings, gangsters

blasting away at each other.
But you're oblivious, a man
who's been struck by an idea—
the way the world might work
if it were given the chance

to take its time. The beauty
of a single task! How gracefully
it all unfolds above your head.
An immense apparatus
of accident and order.

Enthralled, you step across
the perilous hole, amble into a doorway
just as the bullets begin to fly,
then pause to consider
a small breeze, and so escape

12

the piano's conclusive descent.
How long, you wonder, should it take
to accomplish anything? How much
can be included in the process?
A pinwheel and a cord.

A trigger and an arrow. Flame.
Ice. A basin of water and a derby hat.
And a seal, a baby seal.
People will laugh, of course, blind
to such elegance, indifferent

to how well this system keeps the carnation
in your button-hole refreshed. Thus:
the breeze (A) touches the pinwheel (B),
winding the cord that pulls the trigger
that shoots the arrow (F), and so on through

(N) and (O) until the baby seal dives
into its shallow basin and the water spills
onto the flower above your heart.
And if there is no breeze?
If there is no breeze

to start the pinwheel,
sneak up behind a bride and steal
a fresh flower. In her happiness
she will not begrudge you
a single blossom. And perhaps

she will even smile,
as if she hadn't noticed your thick glasses
or your impossible coat, or any of that
crazy contraption balanced
so precariously on your shoulders.

14 Rube Goldberg
Sketch for cartoon, ca. 1960
Pencil on paper
8.5 x 11 inches

CHAIN REACTION

IAN BERRY

A Dialogue ARTISTS IN *CHAIN REACTION* SHARE RUBE GOLDBERG'S FASCINATION WITH AND DISTRUST OF THE MECHANISMS THAT HAVE LED TO INCREASING AUTOMATION AND HUMAN RELIANCE ON MACHINES. RELATING THESE FUNCTIONS TO THOSE OF THE BODY, MANY OF THE ARTISTS SEEK TO EXPOSE SYSTEMS THAT STRUCTURE OUR PHYSICAL SELVES, OUR DESIRES, AND THE WORLD WE CREATE AROUND US. IN AN EFFORT TO CREATE A TEXT THAT WOULD REFLECT THE THEMES OF THE EXHIBITION, I INVITED THE ARTISTS TO PARTICIPATE IN AN ON-LINE DIALOGUE ABOUT THE PROJECT. FROM A VARIETY OF LOCATIONS WE WOULD USE MACHINES TO HELP CONSTRUCT OUR DISCUSSION. OUR CONVERSATION WOULD BUILD ITSELF THROUGH A SERIES OF REACTIONS AND RESPONSES.

FOR SEVERAL WEEKS WE EXPLORED RUBE GOLDBERG'S WORK AND HIS IDEAS, ADDRESSING DIFFERENT WAYS IN WHICH THEIR WORK INTERSECTED OR DIVERTED FROM RUBE'S CARTOONS. THE DIALOGUE BEGAN WITH JEANNE SILVERTHORNE WHOSE SITE-SPECIFIC INSTALLATION GREETED VISITORS TO BOTH MUSEUMS. SHE STARTED WITH A DESCRIPTION OF HER SCULPTURE, LEADING US THROUGH HER EXQUISITE CONFLATION OF MACHINE AND BODY. ARTISTS ADDED TO THE DIALOGUE WITH RESPONSES THAT TOUCH ON PSYCHOLOGY, BIOLOGY, HISTORY, PHYSICS, POLITICS, AND SLAPSTICK HUMOR. A COMMON INTEREST IN THE MACHINE-BODY CONNECTION EMERGED—A NOTION ALSO FOUND IN RUBE'S SEEMINGLY HELPFUL APPENDAGES.

TRYING TO BUILD THE DIALOGUE BECAME MUCH LIKE TRYING TO CREATE A RUBE GOLDBERG INVENTION, AND IN TURN DIDN'T ALWAYS WORK AS PLANNED. THE ONLINE CONVERSATION, WITH ITS UNEXPECTED TECHNICAL DIFFICULTIES, TOOK THE LONG WAY AROUND WHAT MIGHT HAVE BEEN A MUCH SIMPLER TASK. THE PAGES THAT FOLLOW OFFER AN EDITED VERSION OF OUR DISCUSSION.

Jeanne Silverthorne
*072101: The Scream (passing
through bile and butterflies,
encountering alarms, gas, twinges,
fluctuations and surges),* 2001
Rubber and PVC pipe
Dimensions variable
ABOVE: Installation view, Tang
Museum; RIGHT AND OPPOSITE:
Installation view, Williams
College Museum of Art

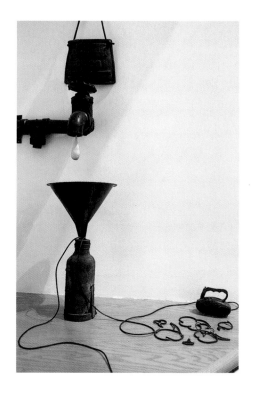

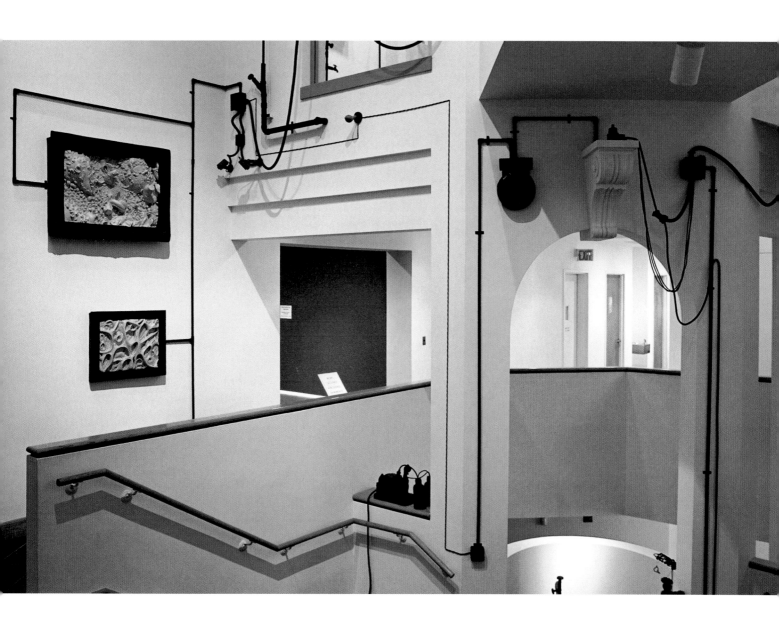

Jeanne Silverthorne First, a description of my piece: *07/02/0l: The Scream (passing through bile and butterflies, encountering alarms, gas, twinges, fluctuations and surges).* As the title suggests, *07/02/01* traces the passage of a scream through the body. Only this body is as much electrical, hydraulic and petro-chemical as it is organic. The piece consists of cast rubber elements and rubber and PVC tubing which will travel up the museum staircase from the lower level, through the atrium to the upper story and finally enter the gallery space. Beginning at the lower level, there are signs that an irritant has entered the system. A small cry of annoyance is mildly amplified, as signified by a miniature cast rubber boom box and tiny rubber cartoon speech bubbles. It enters a receptacle into which a big fat Pavlovian rubber drip falls—drawn no doubt from deep reservoirs always on tap. A suction pump and various circuit breakers and conduits hoist it up to the next plateau. There it is subjected to electrical fluctuations and surges, puffed up by flatulence in the form of a cast rubber gas meter, and narrowed down by valves. A diminutive crane and steam shovel—nano-scavengers, diggers and haulers of the least offense—crank the speech bubbles up the face of a wall.

The rage climbs aloft, under surveillance now by rubber cameras and, setting off various alarms, passes through the meridian of bile and the acidic solar plexus (figured in cast rubber frame images of these regions). A final boost from another engine pumps it into the open mouth (a third rubber frame image of tongue and uvula). The subject is literally beside itself, as manifested by two tiny rubber figures, a redhead and a greyhead, mesmerized by the gaping orifice. Travel through more wires into the gallery proper ends in a speaker trumpet. The voice box is primed: the screams—a collection of large and small rubber speech bubbles—spill out onto the floor.

Roman de Salvo My piece, *Tissue Bank* is a sort of appliance devoted to the withdrawal and deposit of fresh and soiled Kleenex, respectively. It is loosely modeled after ATMs and the human body. A user of the *Tissue Bank* extracts tissue from an orifice, which corresponds to the face, soils the tissue, and then disposes of it in an aperture which corresponds to the bowels. The hygienic disposal procedure involves stepping on a foot pedal, similar to the practice of flushing the toilet with one's foot in a public restroom. The fixture is made of common kitchen countertop materials— Formica, Corian, and stainless steel. The starry-night-colored Corian is routed with concentric ripples around the orifices, to suggest reverberations of a galactic magnitude

Jeanne Silverthorne
072101: The Scream (passing through bile and butterflies, encountering alarms, gas, twinges, fluctuations and surges), 2001
Rubber and PVC pipe
Dimensions variable
Installation view, Tang Museum

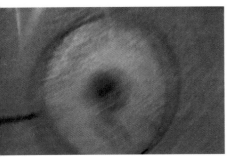

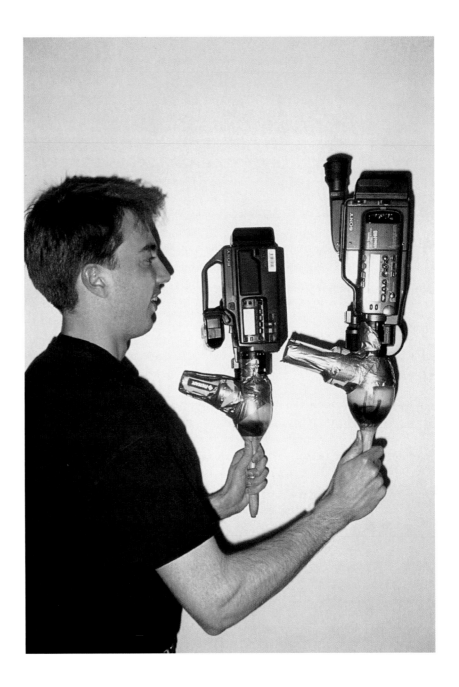

ABOVE AND RIGHT:
Sam Easterson
Video Maracas, 1999
Maracas, cameras, flashlights,
duct tape, two-channel video
transferred to DVD
Dimensions variable

or the idea of a minor act with major ramifications—this innuendo about the blowing of one's nose. If nothing else, the console boosts the ceremony surrounding an otherwise discreet act.

My grandmother was my introduction to Rube Goldberg, not through his art, but through her own household repair improvisations and garden irrigation solutions which she referred to proudly as her Rube Goldbergs. A child of the Depression, my grandmother was a very frugal pack rat who neatly saved every bit of garbage for some later ingenious use. My first experiences of building things were with her guidance. However, I don't feel that it made me a classic Rube Goldberg-type of tinkerer. But her "waste not, want not" ethics as exemplified by her Rube Goldbergs had a deep influence on me which I think can be seen manifested in my *Tissue Bank*, as it has, to my mind, a great deal to do with conscientiousness about material consumption.

Sam Easterson I don't necessarily know a lot about Rube Goldberg's work but I definitely relate to the concept of 'the long way around a simple task.' In my own work, I design and manipulate video cameras so that they can fit inside objects or attach onto animals and plants. For example, to construct the piece that is in *Chain Reaction*, I outfitted a pair of maracas with home video cameras. I cut holes in the top of each maraca and duct-taped the lenses of the video cameras so that they pointed into the holes. This enabled me to see what happened inside the maracas (video cameras) when I shook them.

Almost immediately after coming up with the idea to make this piece, I grabbed the maracas and began cutting holes in them with razor blades. When I realized that that wasn't working, I cut away the wood with a saw. I then used two video cameras that were not mine and taped their lenses to fit into the holes of the maracas. Realizing that I couldn't see inside the maracas because there was no light, I then sprinted down to the drugstore and purchased two overpriced flashlights that I quickly strapped onto the side of each maraca. When I realized that the beans that were inside of the maracas were spilling out of the holes that I made for the flashlights, I then returned to the drugstore again to purchase some sandwich baggies. I then took everything apart and put the baggies over the holes that were there for the flashlights. This kept the beans from spilling out while at the same time allowing for light to reach the interior of the maracas.

In short, it just seems like I shouldn't have had to make two trips to the drugstore to make this piece. I also ruined a lot of razor blades. The fact that the video cameras weren't even mine also meant that I was going to have to take the piece apart

22 Diana Cooper
The Big Red One, 1997
Mixed media on canvas
and wall
124 x 138 x 2 inches

when it was all done anyway. I also don't even really know how to play the maracas. I definitely feel like I took the long way to get to the center of the maracas.

Diana Cooper I will be exhibiting *The Big Red One*. It is a large canvas-based piece with three-dimensional elements attached to the canvas and the wall. The piece combines painting, drawing and sculpture. It is predominantly red (sharpie markers and acrylic paint) and the three dimensional constructions are made of pipecleaners, pom poms, acetate and felt. Sometimes these structures echo the drawn surface of the canvas while at other times they become absurd appendages. I create various types of imaginary systems that often resemble biological forms, architectural diagrams or electrical circuitry. All of my canvas-based pieces have installation manuals that consist of photographs, diagrammatic drawings and text. For *The Big Red One* I am considering a large single drawing that will also function as the installation manual. Rube Goldberg has been mentioned in several reviews of my work. I was familiar with his name as an adjective but had never seen any of his work.

Martin Kersels I don't believe that Rube Goldberg was a conscious influence on the piece *Attempt to Raise the Temperature of a Container of Water by Yelling at It*. But Rube as an ingrained, or should I say imprinted, influence upon how I look at life and therefore by extension an influence on my piece? I would give that an affirmative. As a child I was fascinated with clocks, at least in taking them apart (all that complicated gearing for one function). I loved the game "Mousetrap" (all those devices to rid the world of a pest). Also dominos (all that balance and patience for a moment of pleasure). In general, I was ready for Rube's "machines" that displayed a curmudgeon's world view when I first viewed his cartoons in my early teens (all that cynicism in a fourteen year old boy whose faith in government was shaken by its father, Richard Nixon). Note: the whole Watergate episode became "Goldberg" the moment the security guard discovered the taped-over lock.

I was thinking about the title of the show and how this piece related to it. I can break down the components of *Attempt...* to three parts. A. Sound source connected to B. Beaker of water connected to C. Recording device. This is a chain. But if a chain represents a possible advancement of a situation, then "Attempt..." is not in that model. Part A is fine; part B is fine. But part C is really a mirror of part A. Let's call it A.* So this new chain would really lay out as A-B-A.* Now, why do I see it as such? Part A is the yelling. It is the emotive part of the chain. Part B is the receiver. It is the waste receptacle for the shitty output of A. A* is the thermometer recording the effect A has on B. So, if this makes sense to you, B is the master link of the chain which is the recipient of the shit and examination. This was just an idle thought.

Dean Snyder My contribution to the exhibition is an animation in two versions. Each version has a site of its own. The first will be imbedded within the exhibition catalogue as a flipbook; the second will be cast into the gallery as a cell animation loop. The title of this work is *Tenigo*, which is an out dated psychiatric term for extreme sexual attraction. I came across it in a sex education manual from the 40's; (I collect how to books and *Popular Mechanics* magazines of the post World War Two era).

My earliest encounter with Goldberg's cartoons was in the *Philadelphia Inquirer* newspaper. I was very young and they did not have much currency for me then. I was attracted to the transgressive animation work of Tex Avery, and Max and Dave Fleischer, particularly the early Popeyes and Betty Boops. Later on I was receiving comments over my drawings that included references to Goldberg, that is to say his name was used as an adjective for a particular state of consciousness in my work. This comment has always puzzled me and more often than not feels like avoidance. I mean there are all sorts of sexual content in my heaps of crap and I don't think Rube Goldberg would find any form of flattery by association. The two days I spent looking at his work firsthand in the Williams College Museum of Art archives was an awakening for me. I was struck by the archaic slang in the text and the repressed eroticism underneath his conservative social and political commentary. Aesthetically I was very intrigued with his invented hardware that held the contraptions together. These artifacts in the drawings seemed as punctuation marks within the devices. They felt less static and far more provocative that the other elements. I came away from this experience a little perplexed over how Goldberg's opus has fermented into a classification for proposed futility. *Tenigo* is not proposed futility. The animation is a cycle of a type of sexual attraction and the result is screwing and death. For myself the use of the archaic, tenigo, is a nod to Goldberg's era as well as an opportunity to update his canon to full on lust!

Jovi Schnell I have to admit although I had heard his name before I hadn't seen any of his drawings until just recently. Although when I saw the drawings it felt as if I had seen them before, because they looked so familiar—maybe from all the ACME invention kits from the Road Runner cartoons that I watched as a kid…or any other such toy like thingy jigs. I will be creating a wall painting with relief of cardboard and string. The piece is called *Physical Plant* and is something of an autonomous organica meets mechanica apparatus. The original insight for this piece came from plaques that I saw in numerous elevators while visiting the campus of the University of Tennessee at Knoxville bearing the words "Physical Plant," I knew right away I would do something with the image it conjured.

I was teaching at the time and feeding my students sources that have inspired me including a range of images and readings from Architecture and Biology to Physics and Psychology. Having this

24

"agenda" in mind I imagined the "Physical Plant" as being the University itself, a unified hybrid organism, sprouting various truncations of specialized knowledge, crossbred in-formations branching off sporting new buds of thought. Simultaneously a body, machine, plant and universe. And full of a vigorous and mysterious energy.

William Bergman My piece, *Regret* begins with the cranking of the flywheel. This motion is transferred by chain to a small generator and a gear reducer. The gear reducer then drives the hourglass at a much slower rate than the flywheel. When the generator achieves a high enough voltage it trips a timer on the drilling table. The drill will revolve for a set period of time. Drill revolutions are then counted; after a set number of revolutions the drill moves to the next position. The decision to drill or not to drill is made by the aluminum discs and go/no go switch. This action is repeated (if the flywheel is spinning) until the 798 holes are drilled, revealing the word REGRET in stone.

The mention of Rube Goldberg always brought forth notions of nonsensical machinery for me. He was a cloudy figure whose name appeared every time one of my works had anything kinetic involved. It seemed to go with the territory, although I really did not know who Rube Goldberg was. The name was attached to an image of these machines that did odd tasks in way too many steps. No face or humanity was attached to the name. He was a mystical figure, in my mind. Was he real? Was he an engineer, scientist, artist? I really didn't know until being asked to participate in this show. He seemed to achieve a god-like status. Large numbers of people know of him (or know his name); few seemed to really understand who he really was.

Arthur Ganson I was very familiar with Rube Goldberg's drawings when I was a child and have always enjoyed their absurd practicality, clever invention and 'backwards' problem-solving. I know this affected me at an early age, and I remember making a few absurd chain reaction drawings myself. With respect to making things, I've always tinkered, but only started to make sculpture in college. By this time Rube was very far back in my mind. My first machines were constructed solely out of wire, were very intricate, and always ACTUALLY WORKED.... I stress this because one of the comments I always seemed to get was "Oh, it's like a Rube Goldberg..." to which I would reply (usually just to myself) "No, it's NOT, thank you! Can't you see that he just drew, he didn't have to actually solve REAL mechanical problems!..." and so on. I probably went through a phase where I actually resented him, in an odd sort of way, because so many people knew his work and immediately assumed that I was doing that sort of thing. Now I am not so testy, and I do appreciate all of my many influences. With respect to Rube Goldberg, I think he, (along with Dr. Seuss and all of those Bugs Bunny cartoons) helped create links in my mind between mechanics and humor, and he certainly stretched the notion of just what a mechanical system can be.

The piece which will be included in the show is *Margot's Other Cat*. It is a simple machine (or sys-

Tim Hawkinson
My Favorite Things, 1993
Music box: roasting pan, water
bottle, plant stand, scrounged
bits of metal, motorized;
nine record drawings: gesso, wax,
ink, shellac on paper on board
Overall dimensions variable
(music box: 43 x 17 x 16 inches;
record drawings: 46.5 inches
diameter each)

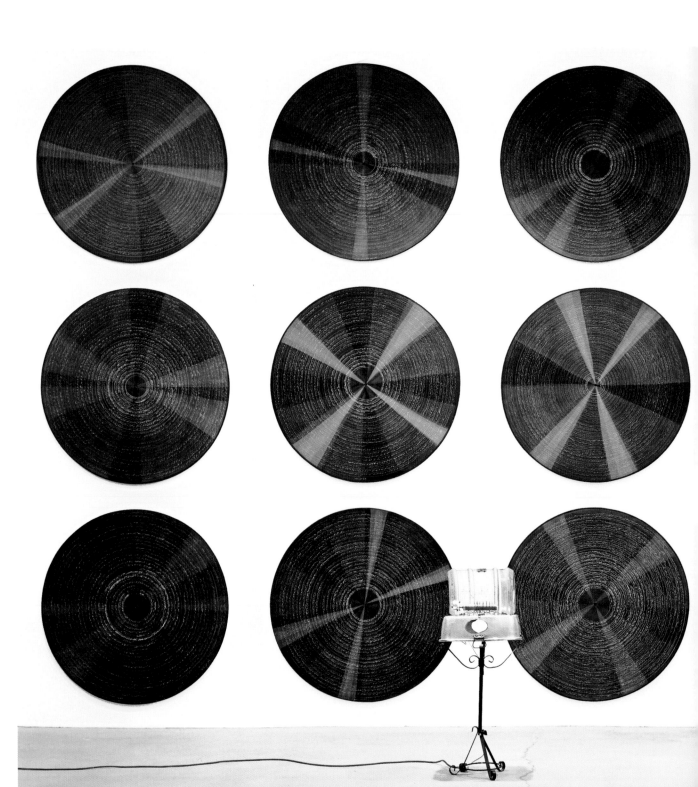

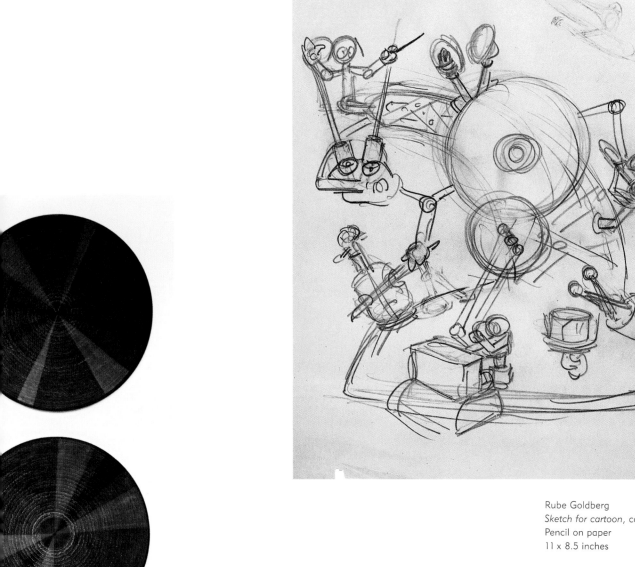

Rube Goldberg
Sketch for cartoon, ca. 1960
Pencil on paper
11 x 8.5 inches

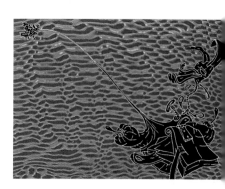

Martin Kersels
Attempt to Raise the
Temperature of a Container of
Water by Yelling at it, 1995
7-gallon glass jar, 5 gallons
distilled water, underwater
speaker, digital recording thermo-
meter, amplifier, CD player,
compact disk, plastic encased
weight, high density foam
rubber, wood, rubber, two tables
Overall dimensions variable
(large table with jar:
54 x 20 x 20 inches; small table
with thermometer: 32 x 15 x
15 inches)

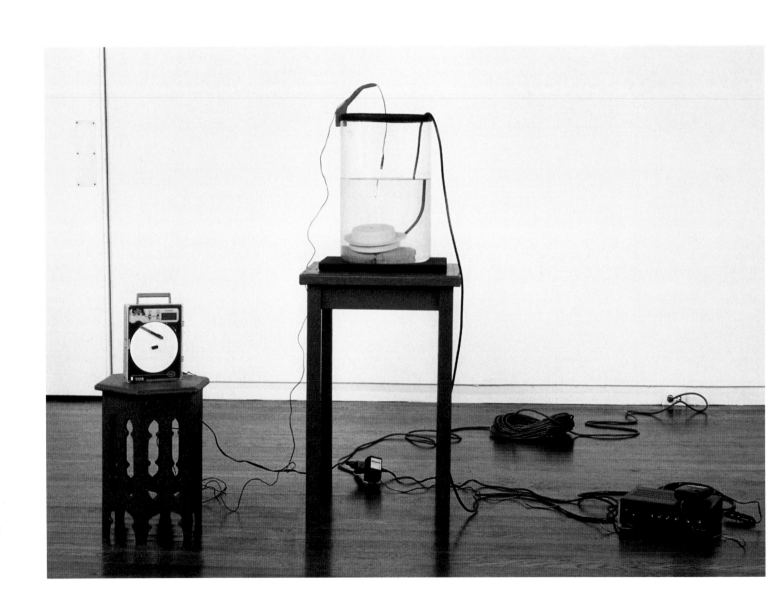

tem) which relates the constant periodic back and forth movement of a small toy cat to the unpredictable and chaotic motion of a small dollhouse sized chair. The chair is counterbalanced and nearly weightless at the end of a small arm. It wants to come to rest, but the cat is continually disturbing it—causing it to roll, tumble, spin and fly through the air. Its motion never repeats while the cat's motion never changes. Of course are many connections between Rube's work and this piece in particular, the most obvious being the intentional humor and an appreciation of the absurd.

Alan Rath My sculpture in the exhibition is called *I Want*. Dating from 1988, it is one of my earlier computer controlled kinetic sculptures. I've always felt that the mechanical design was a bit iffy and thus perhaps Goldbergian. The piece comprises a small video screen with an animated image of a hand mechanically thrusted to and fro by a simple motor and cog belt assembly. The hand repeatedly grasps at nothing. As a child, I would construct elaborate but useless machines from my erector sets—attempting to use every last gear I owned in a single machine. Some people who saw these constructions said they were like Rube Goldberg's machines. This is how I learned of Rube Goldberg. At this age I was also making drawings of improbable machines that adults had also told me looked like something Rube Goldberg would do.

I have to agree with Arthur, that there is a huge difference between a drawing of a machine and a real, actually functioning machine. There is a huge difference between an actual functioning machine and a mock-up of a machine or a simulation of a machine. The actual, real, relentless, functioning of the machine defines "machineness" more than any appearance, purpose, or utility of machinery. There is no way to capture this sense of "machineness" short of building a machine.

Steven Brower I also was aware of Rube Goldberg and have had the experience of making something someone has called "rube goldbergy," and have resented the association. Rube Goldberg is one of those terms people can use instead of thinking about what they are describing. It has always seemed to me that people are not thinking of Rube Goldberg's drawings when they call something a Rube Goldberg. When I hear someone say something of mine, or anyone else's for that matter, is like a Rube Goldberg, I hear "it's not the heat; it's the humidity" and I think the person is not really interested in the thing. The fact is that it would be a very uncommon event to encounter something that's rube goldbergy. I think this is because his stuff is caricature and has little to do with mechanism. His drawings are about lazy people, rich people, stupidity, gluttony, and shit like that. To me, the mechanisms are there to indict the coming domination of industry, and the use of devices toward the ends of lazy people, rich people, stupidity, gluttony et cetera. His drawings always make a proposition at the outset, like "how to solve some kind of specific problem," and then they go on to demonstrate how impossible it really is to solve this problem. And they have a self-satisfied narration, which ignores the role of chance the solution depends on. So when I think of Rube

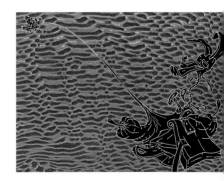

30 Jovi Schnell
Physical Plant, 2001
Acrylic, thread, and collage
on wall
Dimensions variable
Installation view, Williams
College Museum of Art

Goldberg, I think of something more along the lines of a political cartoon. I'm very happy to be associated with political cartoons and not so happy to be associated with mechanisms. I'd rather be a cartoon myself than a robot, I guess.

JOVI, YOU MENTIONED THE IDEA OF MAKING SOMETHING ORGANIC MECHANICAL, OR PLAYING WITH A HYBRID OF BOTH. MANY ARTISTS IN *CHAIN REACTION* ARE ENGAGED WITH THIS COMBINATION. SIMILARLY, MANY OF RUBE'S DRAWINGS INCLUDE BODY EXTENSIONS THAT BUILD OFF THE MAIN CHARACTER. DO YOU START WITH AN ORGANIC BODY OR THE MACHINE? WHAT ABOUT THE HYBRID IS INTERESTING TO YOU?

Jovi Schnell I'm interested in creating forms which draw on both the organic and mechanic simultaneously, by blending the confluences of shape, their functions start to slip in and out of one another and give way to a kind of fusion of metaphor. Sensory devices, scanners, probes, vehicular forms collecting information, relay transmissions, detection instruments...all tasking away as extensions for the wishes of the human body. I'm fascinated, humored by and suspect of these human inventions—particularly ones that derive their templates for applications from organic systems. It makes me curious then if this expression of fusion that I seek between the organic and the mechanic isn't a kind of attempt or aim at some kind of modern day portraiture...a body that is physically adapting to the technology that itself is manifesting. Generally speaking I suppose I create works from a kind of awe of this evolution.

Dean Snyder It is interesting that you bring up portraiture Jovi. I am quite preoccupied with the idea that portraiture as an act necessitates the invention of a new body. I often turn to Collodi's Pinocchio as an example of where I am coming from on this issue. The moment of fusion occurs when in Geppetto's extreme emotional condition he is compelled to satisfy his yearning by making a child from a piece of firewood. The resultant object is a haywire life form void of morals or social consciousness. In my work I consider the heaps of crap as portraits as debris. I have always found the transgressive and pathetic nature of debris exhilarating, and sometimes noble. This may be a slight diversion from the point of Goldberg's project but I do think that those devices are a new body of sorts. They are the people reminding you to take out the trash, mail a letter or the mother that cools off your food and dresses you for school etc. In many ways they are really quite post human as proposed bodies in Professor Butts world. I also think Collodi was the original post humanist. Between the lines of his text lies a social and political commentary as well as a profound understanding as to what drives humans to portraiture.

Arthur Ganson Regarding extensions to the body—(perhaps a little tangential to your comment as I am not referring to things directly attached to the body) I am very aware of how physical references to one's body serve as entry points for association and dreaming on the part of the viewer. They can be subtle but are very strong. Sometimes I use 'human' body parts (so far just doll's heads)

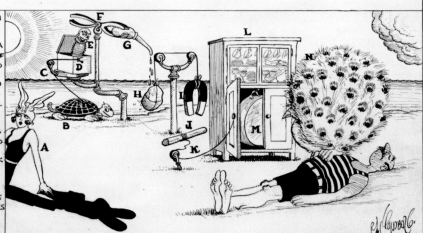

PROFESSOR BUTTS IS OPERATED ON FOR FALLEN ARCHES AND, WHILE UNDER THE ETHER, THINKS OF A HANDY, SELF-WORKING SUNSHADE. SHADOW OF BATHING GIRL (A) CLOSELY RESEMBLES A RABBIT. TORTOISE (B) REMEMBERING THE FABLE OF THE TORTOISE AND THE HARE STARTS TO RACE AND PULLS STRING (C) OPENING HOOK (D) WHICH ALLOWS JACK-IN-THE-BOX (E) TO JUMP AGAINST PLIERS (F) AND SQUEEZE BULB OF EYE-DROPPER (G) WHICH DRIPS WATER ON STONE (H) AS DROPS OF WATER WEAR AWAY STONE CAUSING IT TO BECOME LIGHTER IT RISES ALLOWING MAGNET (I) TO DESCEND. MAGNET ATTRACTS STEEL BAR (J) WHICH LEAVES THE GROUND WITH A SUDDEN JUMP PULLING CORD (K) OPENING DOOR OF CUPBOARD (L) EXPOSING HIGHLY POLISHED POT (M). AS CONCEITED PEACOCK (N) SEES HIS REFLECTION HIS VANITY PROMPTS HIM TO SPREAD HIS BEAUTIFUL TAIL THEREBY SHIELDING BATHER AND PROTECTING HIM FROM SUNBURN — EACH MORNING YOU CAN WRITE THE PEACOCK A LOT OF ADMIRING FAN LETTERS TO MAKE SURE HE IS GOOD AND CONCEITED BY THE TIME YOU NEED HIM.

32 Rube Goldberg
*Professor Butts is operated on
for fallen arches*, ca. 1930
Pen and ink on cardboard
8.25 x 20.5 inches

Jovi Schnell
Physical Plant, 2001
Acrylic, thread, and collage
on wall
Dimensions variable
Installation view, Tang Museum

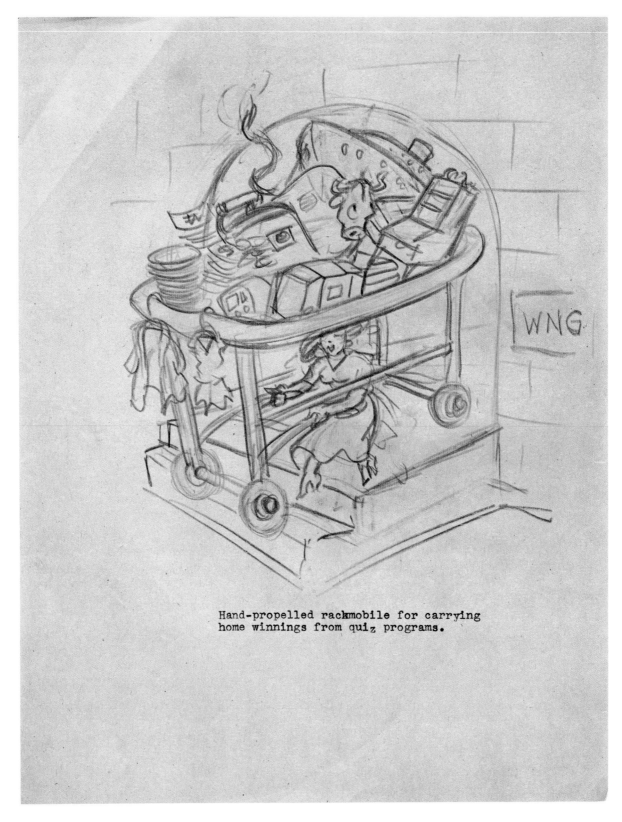

Hand-propelled rackmobile for carrying home winnings from quiz programs.

Rube Goldberg
Hand-propelled rackmobile for carrying home winnings from quiz programs, ca. 1960
Pencil and type on paper
11 x 8.5 inches

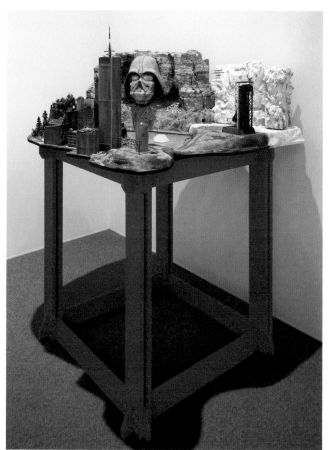

and the association is obvious. In general however, when 'organic' elements are combined with mechanisms; for me they have been things like artichoke petals, cat whiskers, and wishbones, they serve as interesting points of entry. Also, since chairs are so familiar to us they are certainly 'felt' to be a kind of body extension...even if there is no other direct reference.

Alan Rath Many, almost all, of the sculptures I have built meld human body parts (usually represented in digital video) with mechanical structures. Machines and humans co-evolve. Our machinery is an extension of the body. Machinery is collectively generated and employed by humans in much the same way that we share language. Machinery is an essential characteristic of the contemporary human animal. We and machinery are inseparable to the point where it doesn't make much sense to consider one without the other.

Steven Brower It seems to me that Goldberg's machines don't relate to a personal, individual body so much as a social body. There's Pygmalion's sculpture of a woman who becomes infused with life; an image that can be traced through various mythologies like the Golem and Frankenstein, and ending up in something like Arnold Schwarzenegger. Sort of the way an individual's impulse to create gets turned inward, resulting in the individual creating itself. Then there's the little mechanical owl also from Greek mythology, I can't recall his name, but he has analogues in the automata of the 18th century, i.e. de Vaucanson's duck, and the onset of industry which is filled with attempts to replace humans with more reliable equipment. After the Industrial Revolution it seems as though there is this process of going backward and physically scaling down everything that has come before. I think we live now in a period of the miniaturization of machines and also a miniaturization of the idea of the individual. Goldberg operated at the advent of the combination of these two types of body mythology, as in the play *R.U.R.* or the android in *Metropolis*. But his things deal with the fallout of the incompatibility of these body images with social reality. Rather than depict mechanized people, he depicts people's attempts at mechanization. And he shows how futile it is for an individual to attempt to streamline his daily life with makeshift structures, when large-scale industry is the only entity capable of solving these kinds of problems. The drawings of his that I've looked at frequently include a little animal, a bird, a mouse, a cat, which is abused or incarcerated, and also provides motive power to the contraption. It is often the instinct of the animal, which is exploited, and this animal does not have any awareness of the whole device, nor does it care about it. I see these animals as the presence of psychology in the mechanism, the chance that it might break down and as a metaphoric "person" in industrial society. Any references to an individual

Steven Brower
Beyond Good and Evil, 2001
Mixed media
48 x 48 x 64 inches

36 Steven Brower
Beyond Good and Evil, 2001
(detail)
Mixed media
48 x 48 x 64 inches

body, like a shoe at the end of a stick, are dis-articulated and become a remnant of a human being pressed into service as a machine.

Dean Snyder Steven, your observation on the social body versus the individual body is interesting. I do think that there is definitely a social body that emerges through the scattered elements of Goldberg's devices. Given the circumstances of the times, particularly in popular culture, I wonder how influenced he was by Buster Keaton. There is always a second or even third body inferred in Keaton's characters and his commentary is attached to this detached social body as it is tussled and hurled through the film. Keaton built a legacy upon elegantly choreographed catastrophes and for the most part this is what the public saw. Like Keaton I believe that underneath the slapstick edifice of Goldberg's devices there is a very sharp comment being swaged. It may be inappropriate to bring this up but having spent some time with the collection of work in the archives I was quite bowled over at the quantum changes in his style of cartooning and approaches to layout over the course of his career. His allegiance was not to style but to an ideology that was under attack by the forces of change. We as a group seem to be focused on the later works, the ones that have become imbedded in the vernacular American psyche. But there are loads and loads of cartoons prior to these, somewhat forgotten, that comprise a Codex of sorts. In there one can easily see that he had very strong and quite conservative views concerning social behavior between men and women, women in the work place, art and politics. To my mind this is where his social body lies and the slapstick functioned as a second skin over this social body. These late works were velvet hammers.

JEANNE SILVERTHORNE AND DIANA COOPER BOTH SUGGEST THAT MECHANICAL SYSTEMS REMIND US OF OUR PHYSICAL BODIES. I THINK OUR PSYCHOLOGY IS ALSO VERY MUCH AT WORK IN THE REVEALING PROCESS. JEANNE BRINGS UP MEMORY, WHAT OTHER FEARS AND DREAMS EXIST IN MECHANISMS?

Jeanne Silverthorne I think the connection between machine and body is pretty clear here. Perhaps all technology is an attempt to preserve the body from wear and tear, from decay. (In this sense, slaves, or other bodies, were early technologies.) In other words, the ultimate aim of technology is to secure immortality for us. Maybe that's why Rube machines—so inefficient, so overly elaborate—captivate us. For rather than helping us to perfectibility they are themselves invaded by human frailty—more than invaded by—fallibility is their impetus. They consequently perform the useful, even valorous, work of de-sublimation, of remembering. In fact, they enact a literal re-member-ing, recognized as such precisely because the assemblage is so patched, the elements so mis-matched, reminding us of the body's partite nature and questioning the basis of our belief in our wholeness. In a way, Rube's machines inform us, as Lacan does, that our faith in our bodily wholeness is

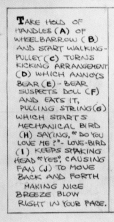
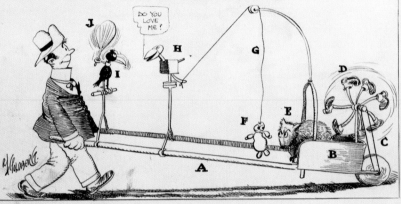
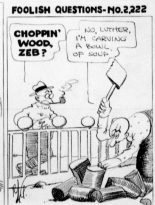

38 Rube Goldberg
*Get one of our patent fans
and keep cool; Foolish
Questions—No.2,222*, ca. 1925
Pen and ink
9 x 20 inches

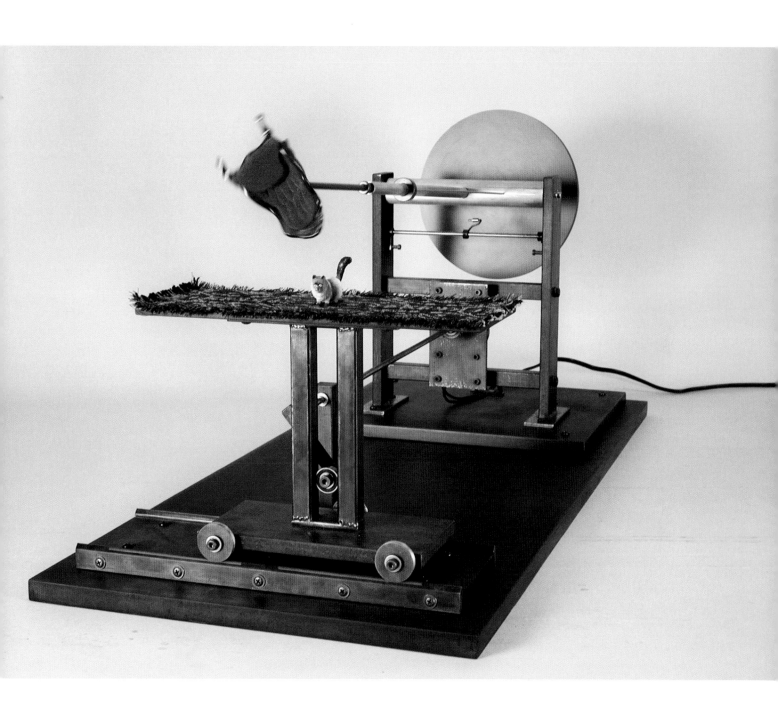

Arthur Ganson
Margot's Other Cat, 1999
Steel, motor, chair, cat
28 x 36 x 14 inches

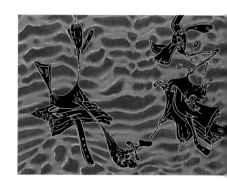

founded on an early misapprehension, for Lacan, epitomized when the infant, held by a caretaker before the mirror, sees itself from the outside for the first time. The child finally understands itself as physically separate but borrows an autonomy for that separateness from the adult with whom it shares the mirror and on whom it is still almost completely dependent. So to be reminded of our "parts," as we are by these ridiculous contraptions, is to be returned to the time before the misprision, to the time when we infants could see ourselves only as a collection of limbs and digits and orifices and protuberances, unable to distinguish between our own and those of our caretakers. In a way, the machine sinks us once again "in our nursling dependency." And although this is a kind of regression, it is also a healthy momento mori. For all their farcicality, Rube Goldberg's systems are reality checks.

Roman de Salvo This discussion of limbs and mirrors reminds me of a fascinating cure for phantom limb syndrome invented by the neuroscientist V.S. Ramachandran. Phantom limb syndrome is a condition suffered by amputees in which they experience intense pain in their missing limbs. The syndrome suggests the profound depth of our belief in the wholeness of our bodies, regardless of what our rational mind tells us. As I understand it, Ramachandran's treatment involves the positioning of mirrors in such a way as to create the appearance of a limb in the place of the missing limb by showing the reflection of the corresponding existing limb. With the illusion of a limb, the patient exercises its existing limb and sees a limb moving where it consciously knows there is none. Regardless, somewhere in the mind, this image registers as proof that the painful cramp is being worked out. And the pain goes away because somewhere deep in the brain, through the illusion of bodily wholeness; the body is allowed to do what the mind likes it to do.

My sense is that belief in the wholeness of the body is fundamental to our being to the point of transcending belief, if that is possible. If we are fascinated by machines as alternative bodies, it might be because of a deep-seated feeling of horror over the idea, which I think the subconscious regards as a form of violence. Remember when, as children, the first time we ever saw somebody with a prosthetic limb?

Dean Snyder You know Jeanne, one of my motives for moving from static images toward animation was the desire to locate some subconscious behavioral traits at work beneath my subjects. Motion made sense to me, as it required this invisible apparatus to make it work, a machine within the body. Making the conscious decision to zoetrope objects was not difficult; however making them appear to have desires was another matter altogether. I was shooting for the sensation that these life forms had just emerged and their movements awk-

ward; they were lonely and groping for an identity. So I was definitely developing the story-line engaging human frailties as the armature from which I could hang these gloms of debris. My goal was to breed debris with dependencies.

I suppose I should qualify what I mean by debris. In the context of this exhibition it would be the stuff that falls out when the action is over or the contraption fails and falls to bits. Natty details, I get big thrills and deep pleasure from the natty details in the aftermath. Aftermath is a central subject in my viewpoint that human intervention upon nature has amplified and enhanced an already enormous beautiful chaotic mess

Martin Kersels I do not want to discount the body—or how physicality plays an important role in Goldberg's drawings, but I would like to propose that this physical aspect is a manifestation of emotional desire. For example, in Rube's drawing *Getting Rid of an Unwanted Guest* the physical set-up is very loose. In fact, it is truly impossible for that specific chain of events to occur. The structure just does not have the physics or engineering behind it (let alone predicting how animals will act or react). But physics and engineering—or animal psychology for that matter—is not what Goldberg is about. I say this next part boldly, and without any research; to him physical is fantasy. And that fantasy belongs to the id.

In the teen party game "post office," a group of teens sits in a circle. One person—let's call him Ian—whispers to the person next to him "I like Monica." That person in turn whispers that message to the next person in line, and so forth. Due to embarrassment, titillation, or laughter the message that finally gets to Monica may sound like "I lick Harmonica." In this case the physical chain does not work, as Ian would maybe like. It breaks at certain weak links. So even though he both fears and desires that this message gets through (and they get married and have two kids) the physical foils the id. In Preston Sturges' film "Unfaithfully Yours" Rex Harrison's orchestra conductor character thinks his younger wife is having an affair with his handsome assistant. His jealousy creates a desire to punish her. He fantasizes about this as he brilliantly conducts his orchestra. The first fantasy involves her murder and the framing of his assistant for that murder. It is a physically complicated fantasy that when flawlessly executed satiates his desire. But when he attempts this plan later that evening he cannot overcome his physical limitations. The murder does not occur and the frame-up fails. But Goldberg does not fail. His pen draws bootstrapped engineered contraptions that work the first time and every time. He, a sort of misanthropic Walter Mitty, is always in control. Skirting small social rules by using devices that distance him from unpleasant situations, he fulfills his desire to see the world rid of boorish people and other nuisances.

Diana Cooper One of my desires was to make a machine that bleeds. In *The Big Red One* I intentionally chose a very saturated red because it was visceral and suggested the interi-

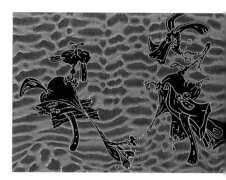

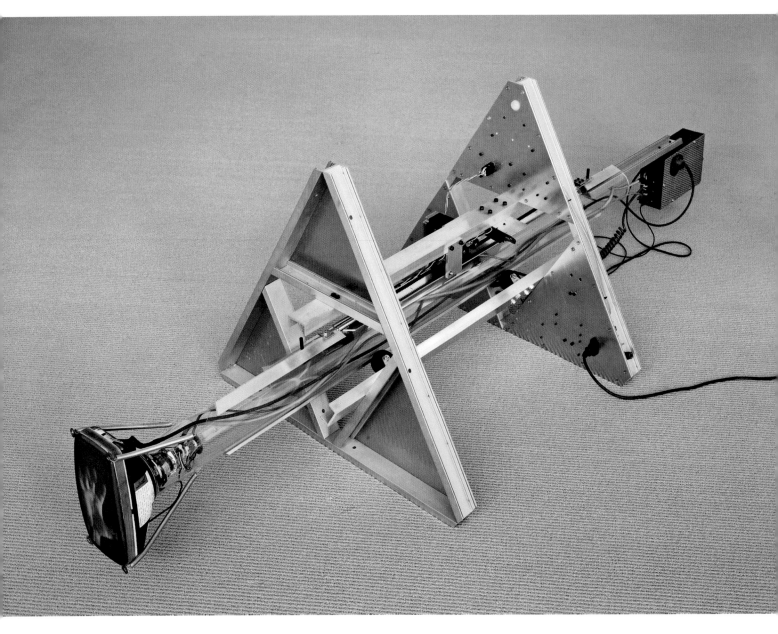

42 Alan Rath
I Want, 1988
Aluminum, acrylic, motor,
electronics, cathode ray tube
25 x 29 x 82 inches

or of the body. On this unlikely surface I drew quasi-technical imagery. I am interested in what exists behind the seamless and protective covering of the machine. I remember going to the Kennedy Space Center and being enthralled by the launch pads. To my uneducated eye, they looked like fantastical constructions that were out of control. I realized how unusual it is to see a machine exposed, with its messy complexity in plain view. Seeing its inner workings gives it the appearance of vulnerability, like seeing a human being without skin. I am interested in highlighting the complexity and vulnerability of both the human body and the machine. In our culture there is a worship of complex machines that I poke fun at in my work. Machines, like the human minds that create them, have a tendency towards excess, a pathological quality I find exhilarating. I am particularly interested in this impulse and how it manifests itself in human behavior and in the machines we create. In the case of the body, excess can lead to frenetic behavior, exhaustion and on the microscopic level to disease. I find beauty, fragility and futility in the malfunctions of the body and the machine. Instead of the reverence commonly given to technology, I want to bring to its representation a degree of irreverence, absurdity and humor. In a sense, I want to bring the viewer back in touch with their body, to basic physical sensations such as sight, touch and the simple act of experiencing art. There is an increasing dependency on the machine that I find both helpful and troubling. I hope to capture the ambiguity of my feelings in my work.

Jovi Schnell The creation of systems does seem to be part of our neurological "wiring" as humans (to use a mechanistic term!). These systems can operate as descriptive models by giving form to complexities that aren't necessarily linear but deemed to be integrated in their underlying structures. An example of this being educational programs that are designed to take an interdisciplinary approach in which information or intelligence is pooled together to gain dynamic insight or elevate consciousness across various pinpointed studies. This kind of coalescence of knowledge may usher in some sense of reaching a dreamy utopic synthesis which holds pattern, meaning, or consonance which I think we can find consoling, interesting, etc. While I can carry a popular fascination with the exports from cognitive science I still hold certain reservations about fully embracing the comparison of the mind to the computer. It may be in vain but I simply cannot believe that the nuances of spirit held in human consciousness are simply computable.

Diana Cooper I have a fear that we will lose sight of the fact that these mechanisms are tools and facilitators and not ends in themselves. My concerns make me think of Lewis Mumford's series of lectures titled *Art and Technics*. They were written in the early 50s but seem eerily pertinent today. He asks the question "why has our inner life become so impoverished and empty, and why has our outer life become so exorbitant, and in its subjective satisfactions even more empty. Why have we become technological gods and moral devils, scientific supermen and esthetic idiots..."

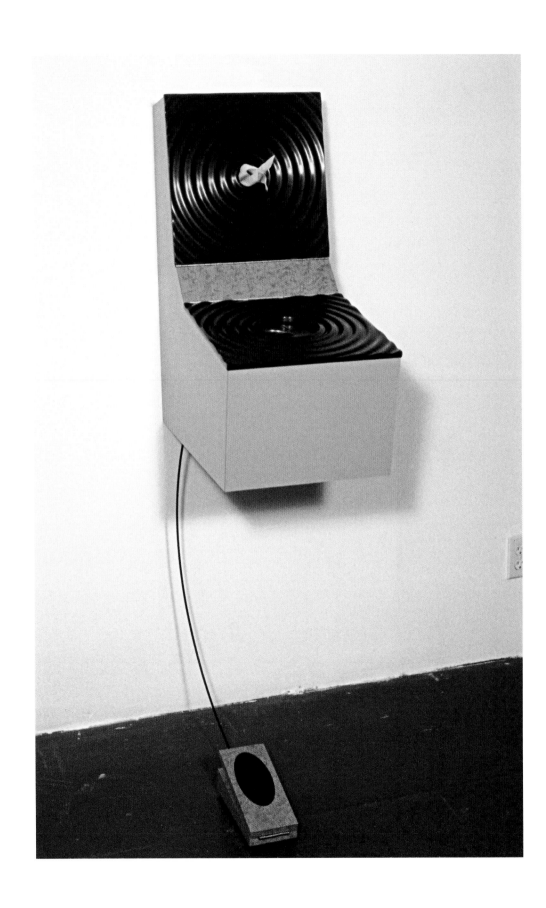

44 Roman de Salvo
Tissue Bank, 1998
Formica, MDF, Corian,
stainless steel, aluminum,
hardware, tissue
57.5 x 13.5 x 23.5 inches

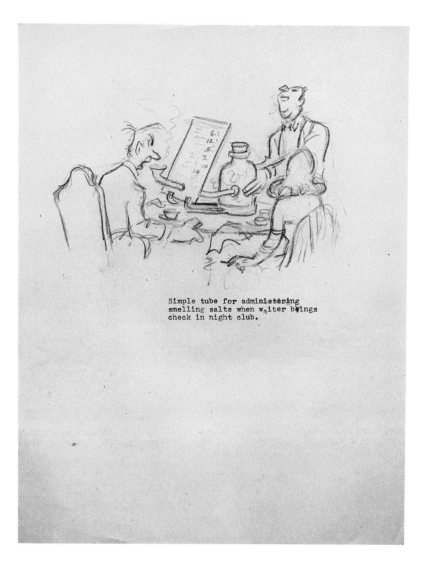

Simple tube for administering smelling salts when waiter brings check in night club.

Rube Goldberg
Study for a simple tube for administering smelling salts, ca. 1960
Pencil on paper
11 x 8.5 inches

Rube Goldberg
Simple tube for administering smelling salts, ca. 1960
Pencil and type on paper
11 x 8.5 inches

46 Roman de Salvo
Tissue Bank, 1998 (details)
Formica, MDF, Corian,
stainless steel, aluminum,
hardware, tissue
57.5 x 13.5 x 23.5 inches

As an aside, it is to interesting to note that Mumford wrote the *Art and Technics* lectures in the aftermath of the most infamous chain reaction (the atom bomb).

In the dialogue, Steve Brower's comment regarding the relationship between the miniaturization of technology and the miniaturization of the idea of the individual made sense to me and speaks to some of my own concerns. Miniaturization makes technology more insidious, ubiquitous and seemingly indispensable. I suppose it is the unseemly marriage of technology and unfettered capitalism that makes me most fearful. Technology is a system of tools, and the more advanced these tools become the more they begin to mimic the complexity of human beings, the pace maker, prosthetic limbs and the auto pilot being obvious examples. I hold onto the dream that art is a system that serves other human needs and desires and its subtlety and power will continued to be valued.

CHAIN REACTIONS HAVE FIGURED IN MANY IMPORTANT MODERNIST WORKS THROUGHOUT ART HISTORY. WHAT ARE SOME THAT ARE INFLUENTIAL TO YOU? FOR ME, THE CONNECTION BETWEEN THE FIGURES IN MARCEL DUCHAMP'S LARGE GLASS, FOR EXAMPLE OR TINGUELY'S MACHINES HAVE BEEN INSPIRING.

Jovi Schnell I find some of Tanguey's contour drawings inspiring, and many paintings by Paul Klee as well. One piece by Max Ernst stands out in my mind as being mysterious and influential—it is a gouache he made in 1920 with imagery from a botanical chart entitled *The Gramineous Bicycle Garnished with Bells the Dappled Fire Damps and the Echinoderms Bending the Spine to look for Caresses.*

Arthur Ganson I have been aware of Duchamp's work since college, and have never been emotionally moved by it. I can see the relationship between the components in the Large Glass, but that understanding for me remains cerebral. Tinguely's work, particularly the earlier work (and not the later work at all) does speak to me on many levels. As a result, he was a strong influence for me. I have never considered his work to really be about 'chain reactions' though...I think the first work that addressed that essential idea was the film *The Way Things Go* by Fischli and Weiss. This I found very beautiful, both for its simplicity and for the fact that it is utterly unpretentious and completely understandable.

Diana Cooper Certain artworks by Paul Klee and Max Ernst come to mind. A contemporary example is Fischli and Weiss's video *The Way Things Go* but I would not cite that as an influence. When I think of chain reactions and their influences on my work, I think of ones that exist outside of art history. The idea of a chain reaction, that one thing leads to another, resembles the way the human body and mind function. In a sense, my mind is using the mechanism of a chain reaction to respond to these questions: one thought is leading to another and so on and so

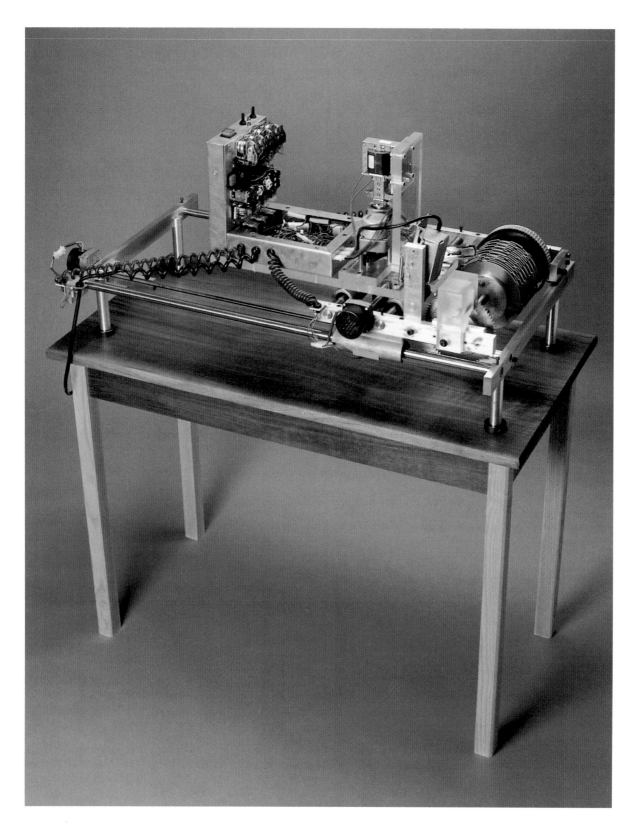

48 William Bergman
 Regret, 2001 (detail)
 Wood, steel, aluminum, glass,
 plastic, limestone, electronics,
 and motors
 Dimensions variable

forth. Both improvisational dance and doodle-based drawing have chain reaction-like qualities and have influenced me. Improvisational dance is unavoidably physical, the body and mind is involved in stringing together a succession of movements that build on preceding ones. When creating a dance through improvisation there is a give and take and a sense of play. Play is a key element in my artwork. My playful use of cause and effect informs many of my artistic choices. Doodle-based drawing is another type of chain reaction. One mark leads to another and another, forms and shapes endlessly proliferate until the conscious mind intercepts, labels and assesses what has been done.

 Roman de Salvo Some of the less spectacular sorts of chain reactions of process oriented sculpture have been influential to me. I think of works such as David Nash's *Cracking Boxes* as having something to do with chain reaction. These boxes are built when the wood is green, and as the wood dries out, the boxes crack and take on a very unstable character. Granted, work such as this involves fewer links in the chain of the chain reaction as say Tinguely's work. But in a more humble form, there is the idea that the work doesn't stay put. Similarly, I've always been fascinated with anecdotes of Gordon Matta-Clark's mold growth experiments. Works such as these by Nash and Matta-Clark are comparatively simple; but they are cause and effect exemplifications that are poetic engagements with growth and/or entropy. While it may not be obvious from my own work, these artists have been very influential to me.

RUBE WAS INVOLVED WITH PERFORMANCE AT DIFFERENT PERIODS OF HIS CAREER. HE APPEARED ON STAGE DRAWING CARTOONS AT VAUDEVILLE THEATERS, WROTE SCREENPLAYS, AND CREATED A SERIES OF SHORT ANIMATIONS FOR SILENT MOVIE THEATERS. WOULD YOU DESCRIBE YOUR WORK AS PERFORMATIVE?

 Arthur Ganson I guess I do see my work as performative. I am not very interested in the objects themselves...it's really the object in 'motion,' over time, so it has to perform to do that. Specifically with respect to 'performance,' I once created a number of large machines which were literally actors on stage in a work called *Shadow of a Doubt*, created in collaboration with the Studebaker Movement Theatre. Here the machines took on a variety of roles and were designed to unfold, move, and act over various time periods throughout the duration of the play. This has lead to the desire, which is still just a dream, of creating an entire theatre work with nothing but mechanisms and 'stuff.'

 Roman de Salvo My piece in *Chain Reaction* is a Kleenex dispenser and disposal fixture called *Tissue Bank*. This is a functional object, so it is to be used—or at least the idea of usage is fundamental to its design. I suppose the idea of usage in the context

BELOW: Rube Goldberg
Sketch for cartoon, ca. 1960,
Pencil on paper
8.5 x 11 inches

RIGHT: Fischli and Weiss
*Flirtation, Love, Passion, Hate,
Separation*,1986
Black and white photograph
12 x 16 inches

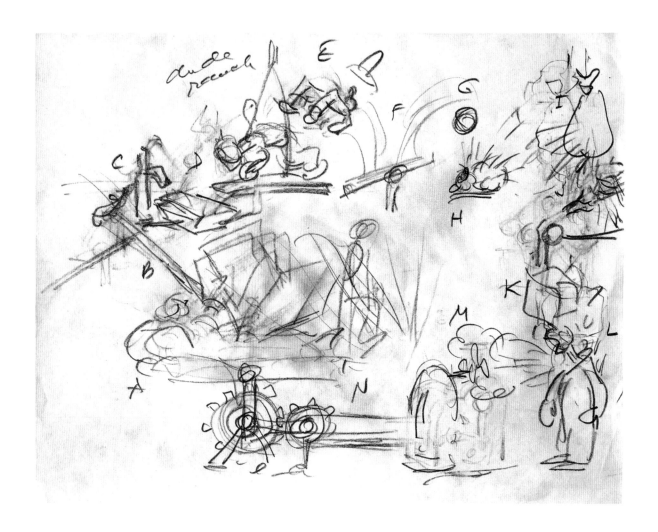

50

Fischli and Weiss
Still from *Der Lauf der Dinge*
(The Way Things Go), 1985–87
Film transferred to DVD
30 minutes

of a museum could also be thought of as "audience participation," which is an aspect of much popular entertainment. So this may have something to do with performance. But I wouldn't overstate it.

William Bergman Human interface has become an integral part of my work. The interaction is necessary to achieve a total understanding of how it works. If the viewer does not interact with the work, only a partial view is possible. Although interaction does not equal understanding.

DOES CHANCE PLAY ANY ROLE IN YOUR WORKS, OR ARE THEY ENTIRELY SCRIPTED BEFORE YOU BEGIN?

Arthur Ganson It feels that for me all ideas are stumbled upon by chance. They often begin as very loose ideas related to some found object or some organizing principle, and the works continue to evolve at every moment. Sometimes it feels like every decision during the development of the piece is stumbled upon. I am always aware that a piece can take many different pathways, and I simply must choose one.

Jovi Schnell My work is entirely planned out in preparatory drawings, which I then set out to construct. They are like blue prints for a house, slight modifications happen along the way when I see room for improvements but they remain close to the original idea. My relationship with chance is a funny one, I suppose I'm starting to trust chance more. What I mean by that is normally I prefer to have "evidence" before my actions, more inductive reasoning, I suppose to some extent this is a result of wanting to have conscious results of what I'm doing. But sometimes this "evidence" comes after the fact, examples such as when researching the various shapes of single cell organisms to work from, I found there were already existing doodles in my sketches that looked almost exactly like these images of diatoms that I was seeing. This citing then turned my drawing from something generally abstract to something specific.

Jeanne mentioned Lacan, not long ago flipping through one of his books that had been recommended to me I glanced a diagram illustrating the rim of the self from which there was a swelling bubble representing the drive or will of the self, again the diagram was almost a complete replica of a recurring motif which I have come to draw that for myself is representative of volcanic activity. Now this kind of thing happens all the time...so chances are one can trust in finding a thread of regularities running through just about everything, it all depends on where you look, being open and ready for it and in some respect giving license to your intuition.

Roman de Salvo In my participatory works such as *Tissue Bank*, in conceiving the piece, I imagine scenarios of interaction. Given that I have no control over what happens to a piece once it's out in the world; there is some degree of surrender to chance. But

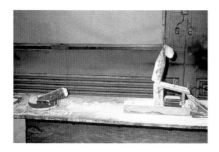

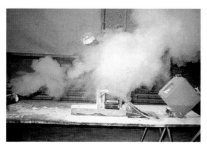

in some way, the design of the piece is like a script in that it has a vernacular relationship to the body, which suggests to the viewer/user/participant the terms of interaction. Still there is a far greater question of chance concerning what meaning the participant makes of the experience. But this is the case with all artwork, isn't it?

William Bergman I am a mechanic at heart. It is the beauty of the machine that is exciting. How it works, how it was made and how it was conceived are all part of the beauty. My process of conception would be similar to how I imagine Rube Goldberg starting a cartoon. I start with the end result and design backwards. The construction of the work is where all of the twists and turns come into play.

Diana Cooper Sometimes I have specific ideas in my head. I may want to convey a psychological state or I may have a certain color or physical structure in mind. But I rarely start out with an exact image of what the piece will look like at the end. If I do, it is almost certain that it will not resemble that image when I am finished. I do not want to feel imprisoned by a preconception in the same way I do not want to live my life according to my preconceptions. The present is a very good place to be but also a very difficult place to be. I feel as though it is in the present that we can experience chance. I invite chance into my work. Without chance so much would be arbitrarily barred from my experience of life and art. However I consciously place limits on the role of chance in my work; I use it and nurture it. At the end of the day, a product of chance will be critiqued at which point it may be severely edited or erased entirely. In other words, it will be treated like any other element.

The making of my work is experiential. If I am aware of what is going on around me I may incorporate something from my immediate environment, whether it be a color in my peripheral vision, a phrase in my head or an accidental mark. I want the open-ended and experiential nature of the process to seep into the work so that the viewer has access to my process and becomes somehow implicated.

Fischli and Weiss
Stills from *Der Lauf der Dinge*
(The Way Things Go), 1985–87
Film transferred to DVD
30 minutes

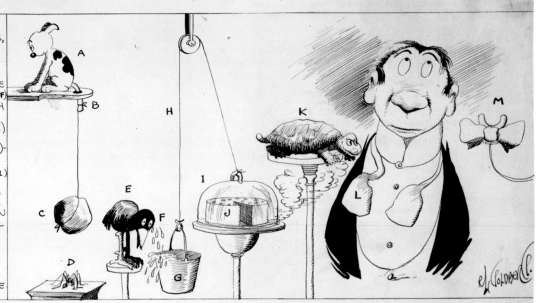

As PUP (A) GROWS, HIS TAIL (B) LENGTHENS, LOWERING ROCK (C), WHICH CRUSHES SPIDER (D) - BIRD (E) WEEPS FOR UNFORTUNATE SPIDER AND TEARS (F) FILL BUCKET (G) WHICH PULLS STRING (H), RAISING GLASS COVER (I) AND EXPOSING LIMBURGER CHEESE (J) - TURTLE (K) GRABS ENDS OF TIE (L) TO FAN HIMSELF WITH AND SWINGS THEM IN ALL DIRECTIONS - WHEN THEY GET TANGLED IN A KNOT, THE TIE WILL LOOK AS WELL AS THE AVERAGE - IF YOU ARE NOT SATISFIED WITH JOB, THROW TIE AWAY AND USE READY-MADE TIE (M).

Now you know how to tie a full-dress tie — by Rube

54 Rube Goldberg
*Now you know how to tie a
full-dress tie*, ca. 1918
Pen and ink on cardboard
8.5 x 13.5 inches

Masterful machines, inane inventions and slapstick schemes are hallmarks of Rube Goldberg's important artwork. His madcap, cartoon contraptions are born of a personal blend of complicated engineering structures and biting vaudeville comedy. While celebrating elemental processes, Rube places his common-man characters into humorous predicaments— how does one get rid of unwanted guests glued to your television set, or carry home humongous prize winnings from a quiz show appearance? To be Rube Goldbergian is to revel in the long way around these potentially simple tasks. His satirical glimpses into everyday life revolve around fantastic inventions that expend all but an ounce of their energy along a tenuous series of interconnected events. Just as we suspect the artist has succumbed to the pure joy of invention and lost his way, the solution is revealed and a punch line is delivered.

It is in Rube's preparatory sketches and original drawings that we catch an unusual glimpse at the tinkerings of a cultural critic at work. The following pages include a selection of Rube's cartoon inventions from the archive of Rube Goldberg material at The Williams College Museum of Art. The earliest in the collection, ca. 1918, is reproduced on your left. Although Rube rarely dated his drawings, we can extrapolate from his biography the periods when he likely completed many of these works. Publication dates often differ as the finished cartoons were syndicated and reprinted in a variety of media.

The first section features inked cartoons on paper and cardboard from the 1920s and early 1930s. Although these were the final versions, they reveal many last minute alterations by the artist. Following the finished cartoons is a group of pencil sketches drawn in the late 1950s and early 1960s after the artist had retired from cartooning and taken up sculpture. These represent Rube returning to the inventions as part of a never completed series of films for television. Multiple stages of many of these scenarios are illustrated here for the first time.

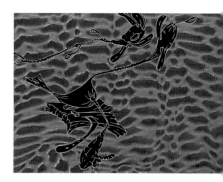

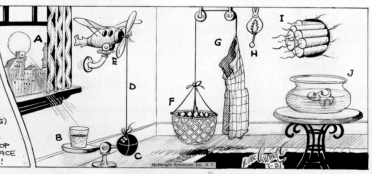

Rube Goldberg
*Professor Lucifer Gorgonzola
Butts invents a simple way to
feed your pet goldfish
when you're away on your
vacation*, 1933
Ink and pencil on paper
7.25 x 20.5 inches

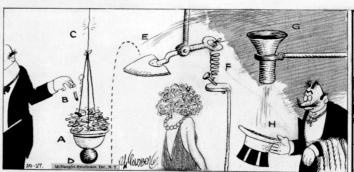

Rube Goldberg
Professor Lucifer Gorgonzola
Butts A.K. invents a
self-emptying ashtray, 1932
Ink and pencil on cardboard
6.25 x 20.5 inches

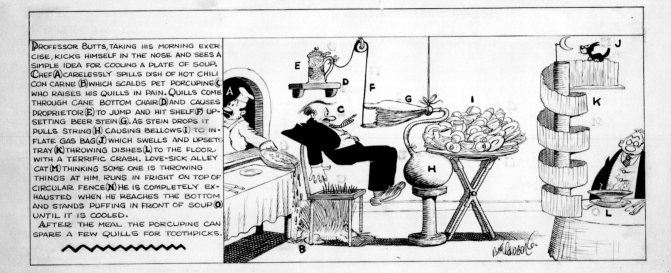

58 Rube Goldberg
Professor Butts, taking his
morning exercise, kicks himself
in the nose and sees a
simple idea for cooling a plate
of soup, ca, 1930
Pen and ink on cardboard
9 x 21 inches

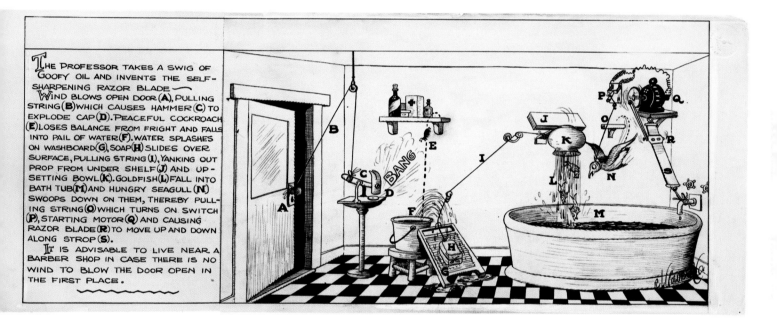

THE PROFESSOR TAKES A SWIG OF GOOFY OIL AND INVENTS THE SELF-SHARPENING RAZOR BLADE—

WIND BLOWS OPEN DOOR (A), PULLING STRING (B) WHICH CAUSES HAMMER (C) TO EXPLODE CAP (D). PEACEFUL COCKROACH (E) LOSES BALANCE FROM FRIGHT AND FALLS INTO PAIL OF WATER (F). WATER SPLASHES ON WASHBOARD (G), SOAP (H) SLIDES OVER SURFACE, PULLING STRING (I), YANKING OUT PROP FROM UNDER SHELF (J) AND UP-SETTING BOWL (K). GOLDFISH (L) FALL INTO BATH TUB (M) AND HUNGRY SEAGULL (N) SWOOPS DOWN ON THEM, THEREBY PULL-ING STRING (O) WHICH TURNS ON SWITCH (P), STARTING MOTOR (Q) AND CAUSING RAZOR BLADE (R) TO MOVE UP AND DOWN ALONG STROP (S).

IT IS ADVISABLE TO LIVE NEAR A BARBER SHOP IN CASE THERE IS NO WIND TO BLOW THE DOOR OPEN IN THE FIRST PLACE.

Rube Goldberg
*The Professor takes a swig
of goofy oil and invents
a self-sharpening razor blade,*
ca. 1930
Pen and ink on cardboard
7.5 x 19.5 inches

PROFESSOR BUTTS EVOLVES HIS LATEST PAINLESS TOOTH-EXTRACTOR IN A STATE OF SCIENTIFIC DELIRIUM.

DENTIST (A) RUSHES OUT OF DOOR (B) INTO STOCK BROKER'S OFFICE NEXT DOOR TO SEE WHAT CONSOLIDATED BOLONEY IS DOING. IN HIS HASTE HE LOSES RUBBER HEEL (C) WHICH BOUNCES INTO CUP (D), TIPPING LEVER (E) WHICH PULLS STRING (F) UPSETTING BAG OF PEANUTS (G). SQUIRREL (H) REVOLVES CAGE (I) IN MAD ATTEMPT TO GRAB PEANUTS AND CAUSES PISTON (J) TO WORK BELLOWS (K) MOTION OF BELLOWS LIFTS COVER (L) AND AT THE SAME TIME BLOWS FUMES OF LIMBURGER CHEESE (M) IN FACE OF PATIENT, KNOCKING HIM COLD. VIBRATIONS OF HIS HEAD WHILE SNORING CAUSE STRING (N) TO PULL DELICATE PROP (O) FROM UNDER SHELF (P) AND SUDDEN DROP OF WEIGHT (Q) RESULTS IN WIRE (R) PULLING TOOTH. FALLING WEIGHT ALSO CAUSES PADDLE (S) TO TOSS GLASS OF WATER (T) INTO PATIENT'S FACE TO REVIVE HIM.

IF HE HAS NOT REVIVED WHEN THE DENTIST COMES BACK THREE DAYS LATER, THE GRAND JURY WILL HAVE TO DECIDE WHO IS TO BE TRIED FOR MURDER, THE DENTIST OR THE MAN WHO SOLD HIM THE LIMBURGER CHEESE.

60 Rube Goldberg
Professor Butts evolves his latest painless tooth-extractor in a state of scientific delirium, ca. 1930
Pen and ink on paper
7.5 x 19.5 inches

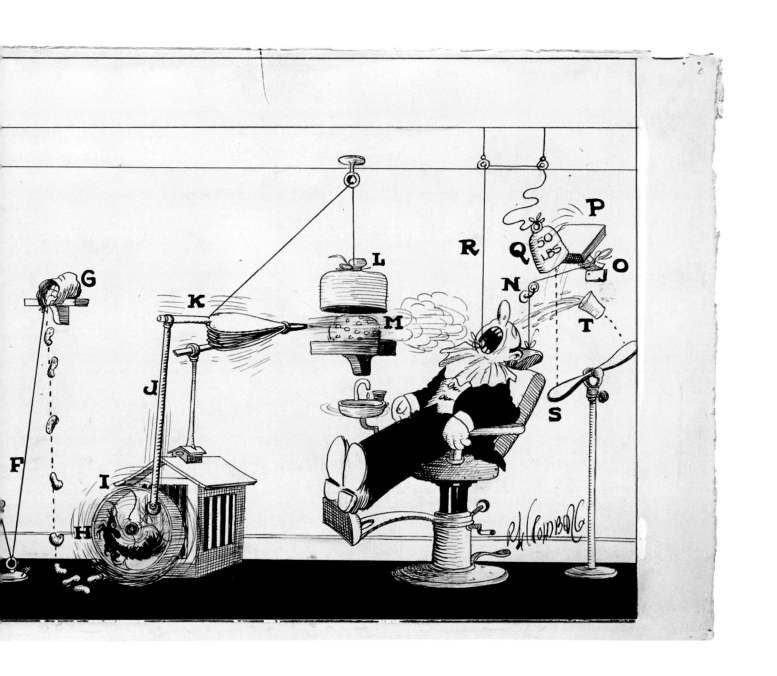
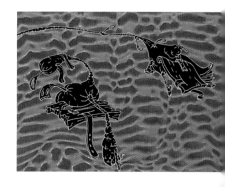

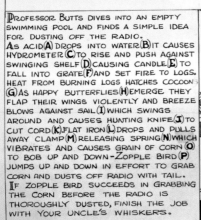
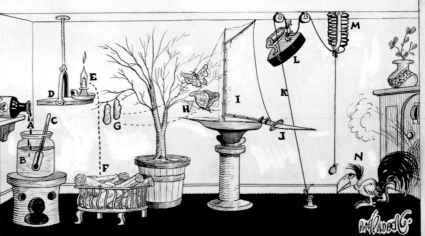

PROFESSOR BUTTS DIVES INTO AN EMPTY SWIMMING POOL AND FINDS A SIMPLE IDEA FOR DUSTING OFF THE RADIO.

AS ACID (A) DROPS INTO WATER (B) IT CAUSES HYDROMETER (C) TO RISE AND PUSH AGAINST SWINGING SHELF (D) CAUSING CANDLE (E) TO FALL INTO GRATE (F) AND SET FIRE TO LOGS. HEAT FROM BURNING LOGS HATCHES COCOON (G) AS HAPPY BUTTERFLIES (H) EMERGE THEY FLAP THEIR WINGS VIOLENTLY AND BREEZE BLOWS AGAINST SAIL (I) WHICH SWINGS AROUND AND CAUSES HUNTING KNIFE (J) TO CUT CORD (K). FLAT IRON (L) DROPS AND PULLS AWAY CLAMP (M) RELEASING SPRING (N) WHICH VIBRATES AND CAUSES GRAIN OF CORN (O) TO BOB UP AND DOWN—ZOPPLE BIRD (P) JUMPS UP AND DOWN IN EFFORT TO GRAB CORN AND DUSTS OFF RADIO WITH TAIL.

IF ZOPPLE BIRD SUCCEEDS IN GRABBING THE CORN BEFORE THE RADIO IS THOROUGHLY DUSTED, FINISH THE JOB WITH YOUR UNCLE'S WHISKERS.

62 Rube Goldberg
Professor Butts dives into an
empty swimming pool
and finds a simple idea for
dusting off the radio, ca. 1930
Ink on paper
9 x 21 inches

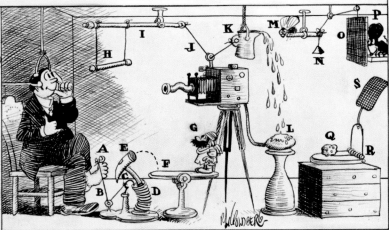

PROFESSOR BUTTS GOES OVER NIAGARA FALLS IN A COLLAPSIBLE ASH-CAN AND HITS UPON AN IDEA FOR A SIMPLE WAY TO TAKE YOUR OWN PICTURE.

WIGGLE BIG TOE (A), PULLING STRING (B) AND RAISING HOOK (C), WHICH RELEASES SPRING (D) AND CAUSES HAMMER (E) TO STRIKE PLATFORM (F) AND CATAPULT ARABIAN MIDGET (G) TO TRAPEZE (H). WEIGHT OF ARAB CAUSES BAR (I) TO TILT AND PULL CORD (J), WHICH UPSETS PITCHER OF SYRUP (K). SYRUP DRIPS ON CAMERA-BULB (L) ATTRACTING HUNGRY FLY (M) WHICH SWOOPS DOWN, ALLOWING WEIGHTED END OF BAR (N) TO LIFT SCREEN (O) WHICH HAS BEEN SHUTTING OFF VISION OF MOUSE (P). MOUSE SEES CHEESE (Q) AND JUMPS. TRAP (R) SNAPS, CAUSING SWATTER (S) TO SWAT FLY THEREBY SQUEEZING BULB & TAKING PICTURE. IF PICTURE IS NO GOOD DON'T BLAME IT ON INVENTION. IT'S THE WAY YOU LOOK.

Pub. Dec. 19/31

Rube Goldberg
*Professor Butts goes over
Niagara Falls in a collapsible
ash-can and hits upon an
idea for a simple way to
take your own picture,* ca. 1930
Ink and pencil on paper
9.25 x 20.75 inches

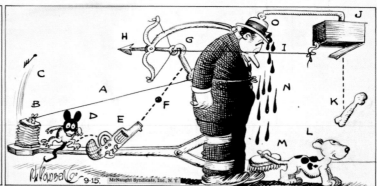

Rube Goldberg
Professor Lucifer Gorgonzola
Butts A.K. invents simple
self-shining shoes, ca. 1930
Pen and ink on cardboard
6.25 x 18.5 inches

Rube Goldberg
Bill and Boob McNutt, 1932
Pen and ink on paper
24 x 19 inches

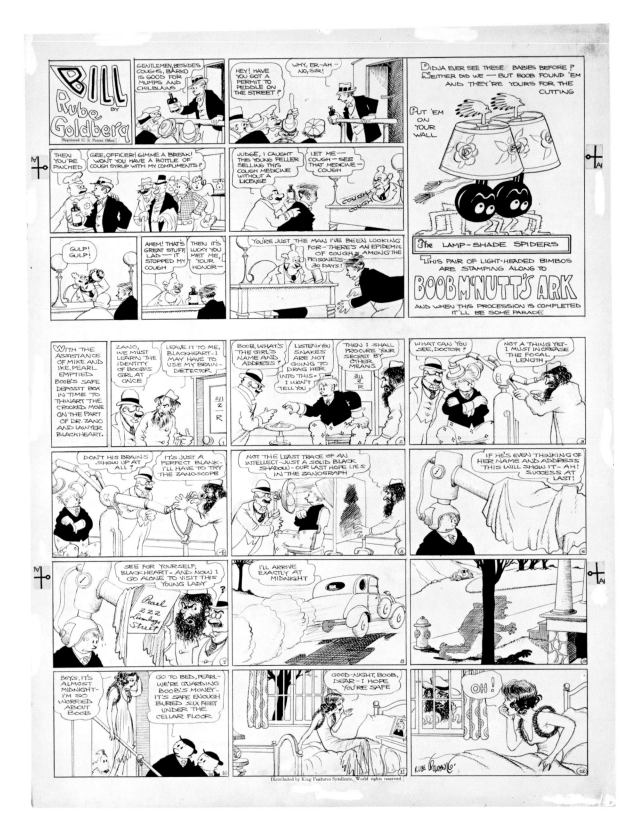

66 Rube Goldberg
Bill and Boob McNutt, ca. 1930
Pen and ink on paper
24 x 19 inches

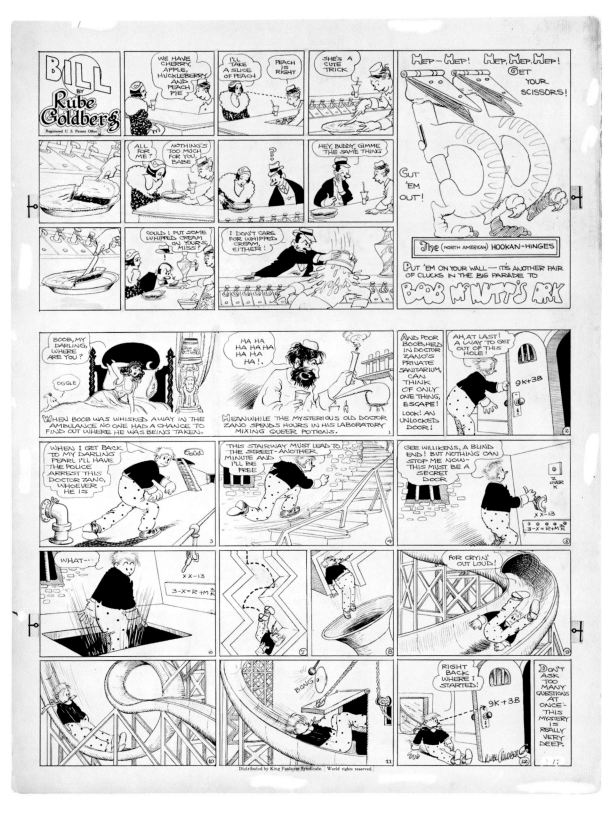

Rube Goldberg
Bill and Boob McNutt, ca. 1930
Pen and ink on cardboard
24 x 19 inches

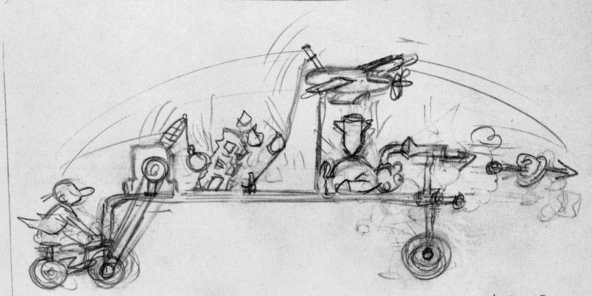

68 Rube Goldberg
How to recover hat that flies off,
ca. 1960
Pencil on paper
8.5 x 11 inches

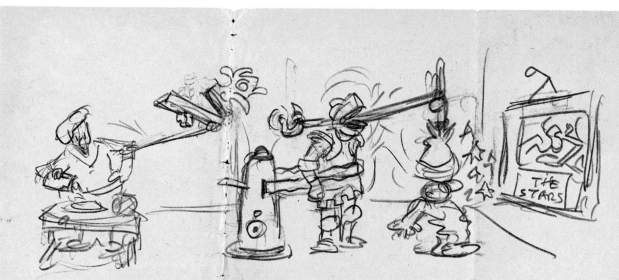

ARTIST MAKES HIMSELF A PEANUT BUTTER SANDWICH
TIPPING SHELF AND DROPPING MODERN SCULPTURE
ON SWITCH WHICH STARTS ELECTRIC VIBRATOR-
VISOR ON SUIT OF ARMOR SNAPS ROPE ALLOWING
SANDBAG TO DROP ON SPECTATORS HEAD-
HE SEES STARS MAKING TITLE OF ABSTRACT
PAINTING CORRECT

Rube Goldberg
Artist makes himself a peanut
butter sandwich, ca. 1960
Pencil on paper
8.5 x 11 inches

70 Rube Goldberg
 Instant noodle cutter, ca. 1960
 Pencil on paper
 8.5 x 11 inches

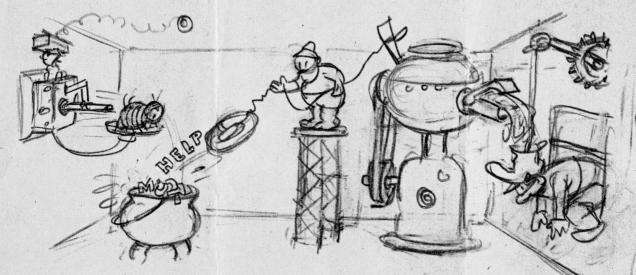

WHEN BURGLAR PASSES INVISIBLE ELECTRIC
EYE OUTSIDE WINDOW, POOL CUE ON OTHER SIDE
OF ROOM PUSHES JAPANESE BEETLE INTO KETTLE
OF ALPHABET SOUP— LETTERS SPLASH "HELP!" AND
LIFE SAVER TOSSES PRESERVER TO BEETLE, STARTING
CEMENT MIXER WHICH FILLS BOOT WITH CEMENT
DROPPING IT HEAVILY ON HEAD OF BURGLAR
LEAVING PLENTY OF TIME TO CALL POLICE.

Rube Goldberg
Our special burglar alarm,
ca. 1960
Pencil on paper
8.5 x 11 inches

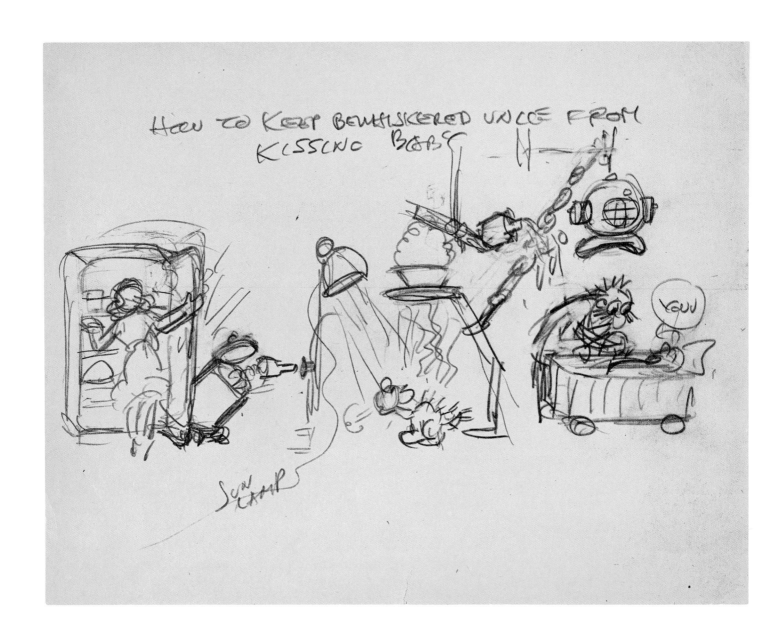

Rube Goldberg
How to keep bewhiskered uncle
from kissing baby, ca. 1960
Pencil on paper
8.5 x 11 inches

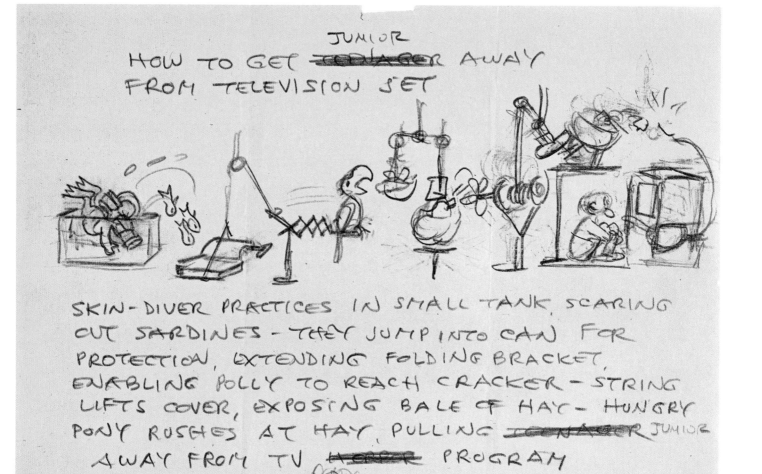

HOW TO GET JUNIOR ~~TEENAGER~~ AWAY FROM TELEVISION SET

SKIN-DIVER PRACTICES IN SMALL TANK, SCARING OUT SARDINES - THEY JUMP INTO CAN FOR PROTECTION, EXTENDING FOLDING BRACKET, ENABLING POLLY TO REACH CRACKER - STRING LIFTS COVER, EXPOSING BALE OF HAY - HUNGRY PONY RUSHES AT HAY, PULLING ~~TEENAGER~~ JUNIOR AWAY FROM TV ~~JUNIOR~~ PROGRAM

Rube Goldberg
How to get junior away from television set, ca. 1960
Pencil on paper
8.5 x 11 inches

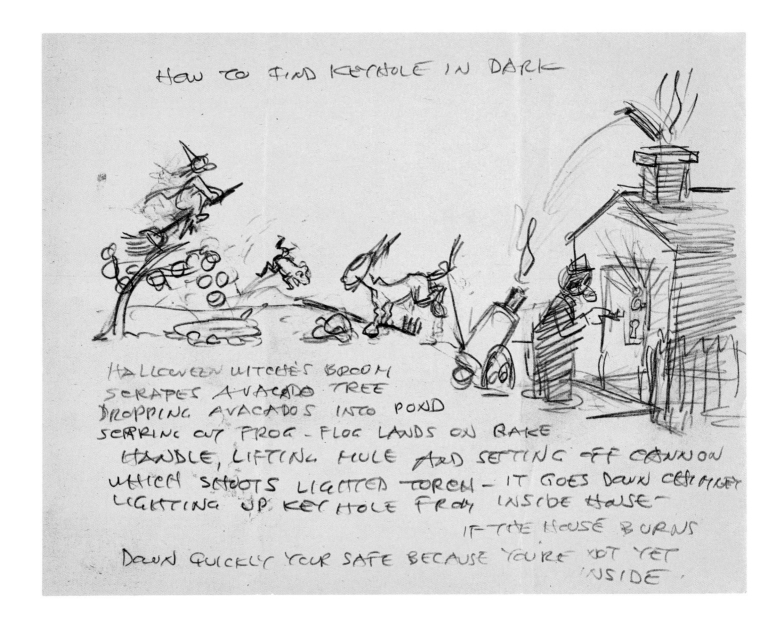

HOW TO FIND KEYHOLE IN DARK

HALLOWEEN WITCHE'S BROOM
SCRAPES AVACADO TREE
DROPPING AVACADOS INTO POND
SCARRING OUT FROG - FROG LANDS ON RAKE
HANDLE, LIFTING HOLE AND SETTING OFF CANNON
WHICH SHOOTS LIGHTED TORCH - IT GOES DOWN CHIMNEY
LIGHTING UP KEY HOLE FROM INSIDE HOUSE

IF THE HOUSE BURNS

DOWN QUICKLY YOUR SAFE BECAUSE YOU'RE NOT YET
INSIDE.

74 Rube Goldberg
How to find keyhole in dark,
ca. 1960
Pencil on paper
8.5 x 11 inches

MOUSE DIVES AS PAINTING OF PIECE OF CHEESE
GOES THROUGH CANVAS INTO BUCKET OF HOT
WATER - RUNS UPSTAIRS TO COOL OFF HITS HIS
HEAD ON LOW CEILING AND FALLS ON BOXING GLOVE
TAKES COUNT ON COUCH WHERE HE DIES
PEACEFULLY SURROUNDED BY ESCAPING GAS
BOUNCES TO BASKET SETTING OF POLARIS
MISSILE WHICH TAKES HIM TO MOON.

Rube Goldberg
*Mouse dives at painting
of piece of cheese*, ca. 1960
Pencil on paper
8.5 x 11 inches

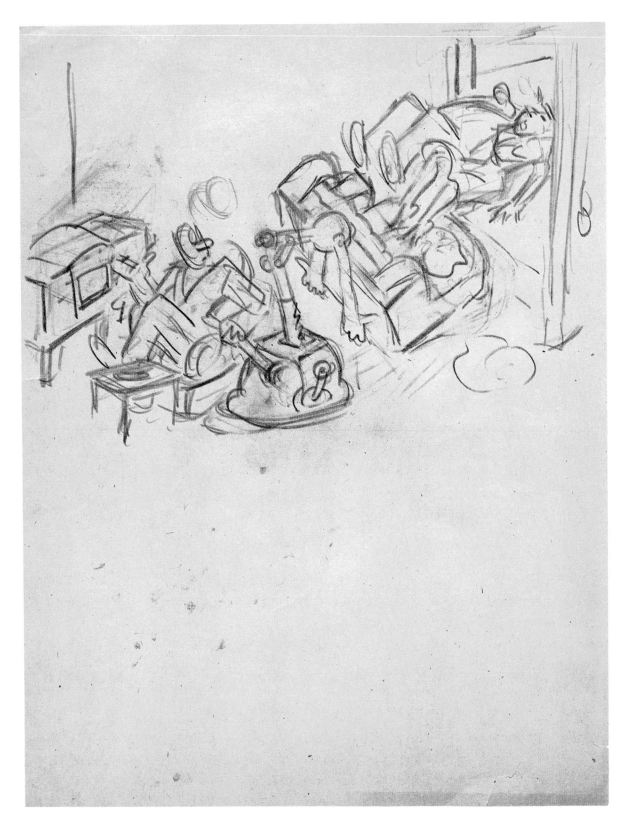

76 Rube Goldberg
*Study for simple one-shift
bouncer*, ca. 1960
Pencil on paper
8.5 x 11 inches

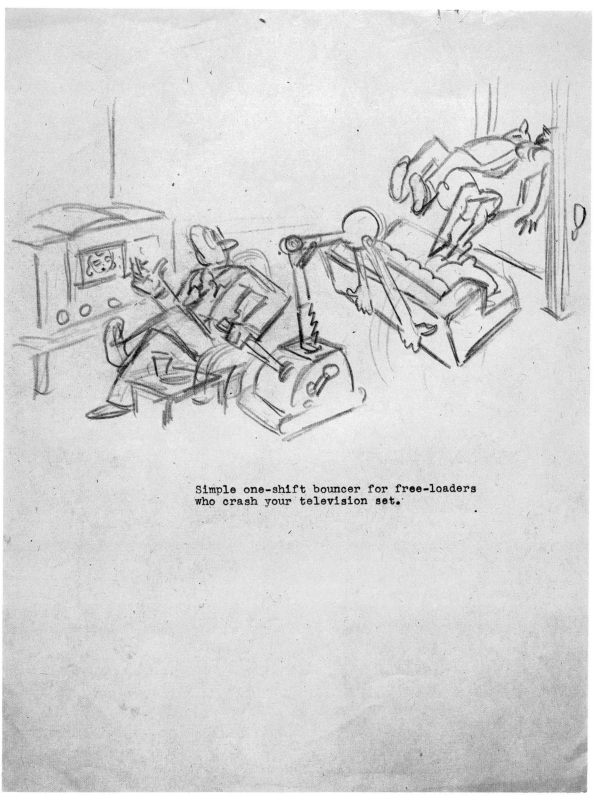

Simple one-shift bouncer for free-loaders
who crash your television set.

Rube Goldberg
Simple one-shift bouncer,
ca. 1960,
Pencil and type on paper
11 x 8.5 inches

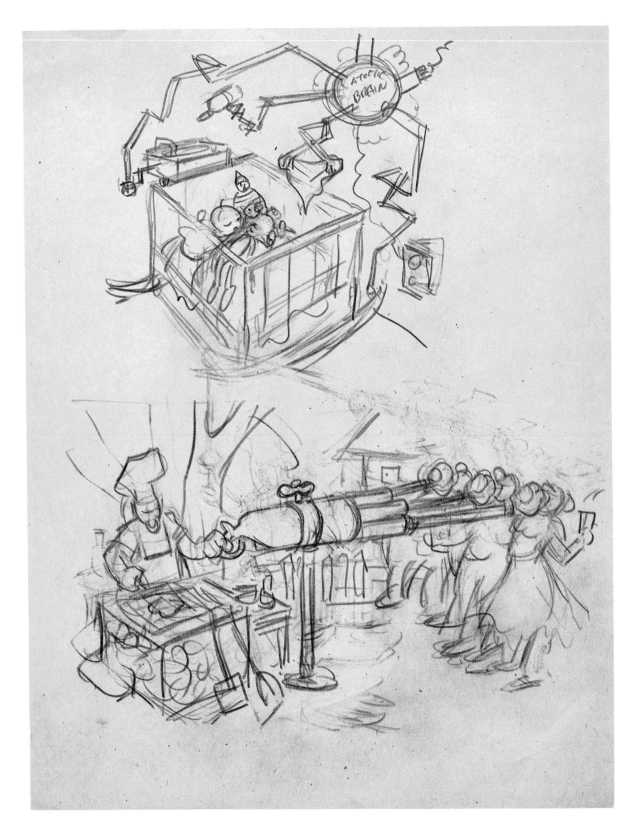

78 Rube Goldberg
*Study for quick-action
gun to quiet guests and robot
babysitter,* ca. 1960
Pencil on paper
11 x 8.5 inches

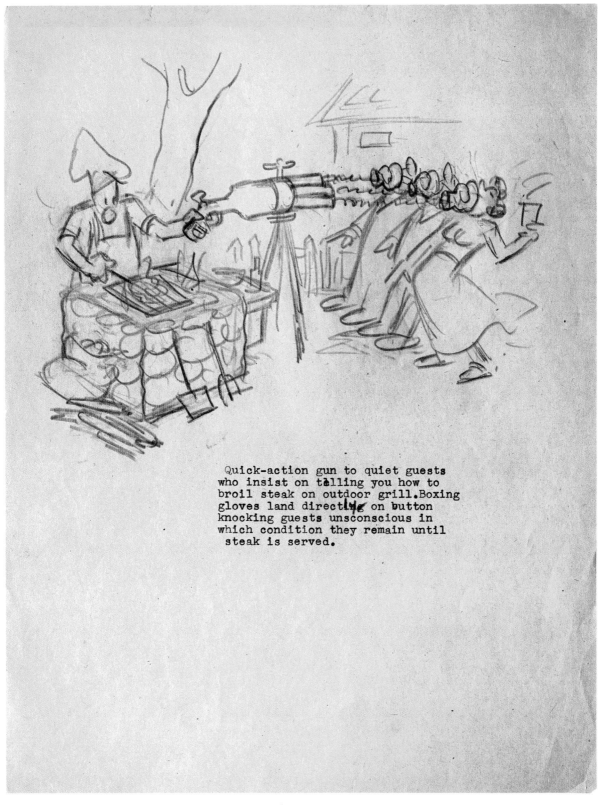

Quick-action gun to quiet guests who insist on telling you how to broil steak on outdoor grill. Boxing gloves land directly on button knocking guests unsconscious in which condition they remain until steak is served.

Rube Goldberg
Quick-action gun to quiet guests, ca. 1960
Pencil and type on paper
11 x 8.5 inches

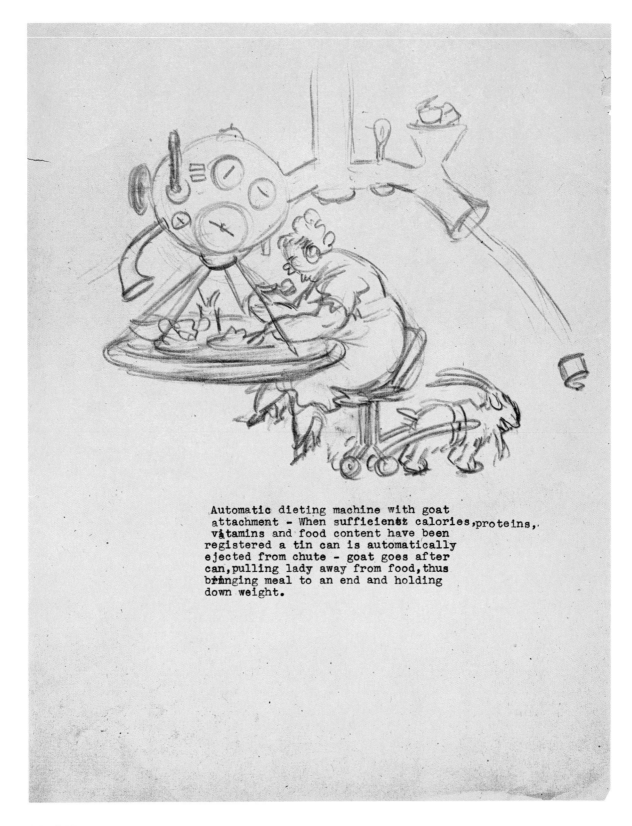

Automatic dieting machine with goat attachment - When sufficient calories, proteins, vitamins and food content have been registered a tin can is automatically ejected from chute - goat goes after can, pulling lady away from food, thus bringing meal to an end and holding down weight.

Rube Goldberg
Automatic dieting machine with goat attachment,
ca. 1960
Pencil and type on paper
11 x 8.5 inches

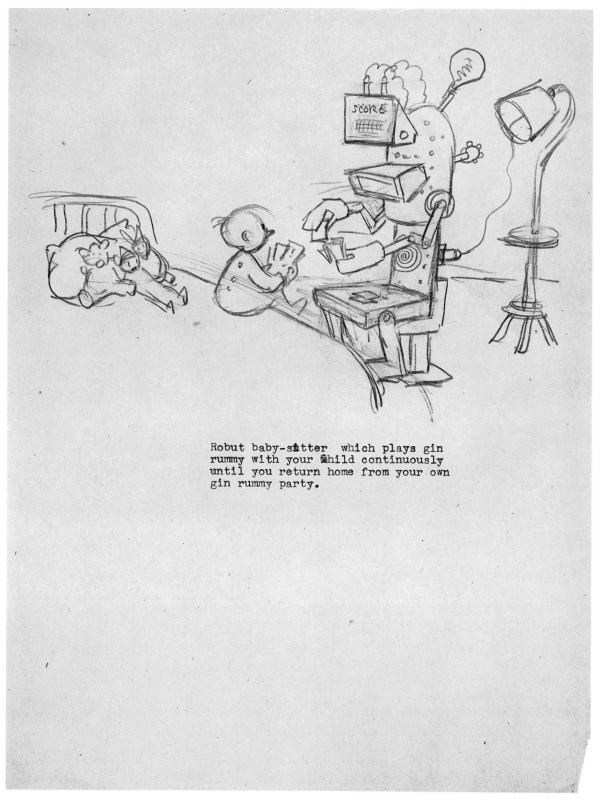

Robut baby-sitter which plays gin
rummy with your child continuously
until you return home from your own
gin rummy party.

Rube Goldberg
Robut [sic] *baby-sitter which*
plays gin rummy, ca. 1960
Pencil and type on paper
11 x 8.5 inches

Rainmaker (A) leans back to look at flying saucer(B)
sprinkling dry ice(C) into cloud(D),making rain(E)
which falls on surplus potato(F),raising canele(G)
which lights fuse onzStromboli (H) on Stromboli(I) -
Stromboli erupts Harry Bridges(J) who hits piece
of Australia(K) cause baseball glove(L) to throw
curve - Joe Di Maggio(M) swings and misses,causing
spool (N) to revolve,starting windless(O) which
pulls shirt off taxpayer's back(Q).

Truman(A) starting off on another vacation,causes
string (B) to light up movie actress(C) - Congressman(D),
investigating movie morals gets excited and falls on
switch(

Truman(A),starting off on another vacation,causes
string (B) to turn spotlight(C) on movie actress(D)-
Congressman(E),investigating Hollywood morals,gets
excited and falls back on switch((F),starting atomic
machine((G) which causes umbrella((H) to knock over
butket (I) and spill red herring(J) into FBI net(K)-
extra weight cause series of rods(L) to dump load
of political gold bricks onztaxzpaterfrom hod((M) on
head of taxpayer (O) knocking him cold.

Cross
nib feel
98
930

82 Rube Goldberg
Texts for cartoons, ca. 1960
Type on paper
11 x 8.5 inches

Rube Gold•berg (rōob' gōld'bûrg') *adj.* Of, relating to, or being a contrivance that brings about by complicated means what apparently could have been accomplished simply.

— *THE AMERICAN HERITAGE DICTIONARY OF THE ENGLISH LANGUAGE*, THIRD EDITION

Reuben Lucius Goldberg, born on July 4th in 1883, was an eccentric figure whose early training as a draftsman and engineer led him to an illustrious career as a pioneer cartoonist. He completed over 50,000 single panel cartoons and comic strips over six decades that appeared in newspapers from California to New York.

Rube received a B.S. degree from the University of California, College of Mining Engineering in 1904, the same year his first cartoons appeared on the sports page of the *San Francisco Chronicle*. In 1906 he began drawing for the *San Francisco Bulletin* and one year later moved to New York and began work at the *Evening Mail*. His first invention, an automatic weight-reducing machine, was printed in 1914, and for the next fifty years he would draw the series of inventions for which he is best known. They featured such devices as the *Invention for Keeping a Buttonhole Flower Fresh*, in which a tangle of tubing connects items such as an arrow, pinwheel, cigar lighter, and block of ice that together nourish the flower pinned to the hapless Professor Butts coat lapel (see pages 10–11).

Although his inventions were certainly the most famous of his cartoons, Rube drew sixty-one different series that overlapped years and were often grouped within a single daily strip. His longest running titles continued amidst prolific work in other media such as vaudeville theater, short stories, song lyrics, and scripts for films, including *Soup to Nuts* for the Three Stooges. Rube's art brought him fame, fortune, and many accolades, including the Pulitzer Prize in 1948 for his editorial cartoon, *Peace Today*.

An advocate for cartoon artists and one of the earliest proponents of comic ownership by the artists and syndications, Rube tirelessly promoted the artform. He founded the National Cartoonist's Society in 1946, served as its president, and continues to be immortalized as their highest annual award is referred to as the "Reuben." Late in life he started a new career as a sculptor, creating approximately 300 works inspired by Daumier and Rodin. His sculptures were eagerly shown in New York galleries and proved to be yet another success for the artist before his death at age 87 in 1970.

RUBE GOLDBERG SELECTED BIBLIOGRAPHY

Garner, Philip. *Rube Goldberg: A Retrospective*. New York: Putnam, 1983.

"Goldberg—His Crazy Inventions Confront the Postwar." *Life*, November 27, 1944, p. 76.

Goldberg, Reuben Lucius. *Bobo Baxter: The Complete Daily Strip 1927–1928*. With an introduction by Bill Blackbeard. Connecticut: Hyperion Press, 1977.

_____. *Chasing the Blues*. New York: Doubleday, Page & Co.,1912.

_____. *Foolish Questions*. Boston: Small, Maynard & Co., 1909.

_____. *How to Remove the Cotton from a Bottle of Aspirin and Other Problems Solved*. Garden City, New York: Doubleday & Co., 1959.

_____. *Is There a Doctor in the House?* New York: John Day Co., 1929.

_____. *Seeing History at Close Range: The Experience of an American Cartoonist While Marooned in France During the Outbreak of the Present European War*. New York: Morris Margulies, 1914.

_____. *The Rube Goldberg Plan for the Post-War World*. New York: Franklin Watts, 1944.

Goldberg, Rube and Sam Boal. *Rube Goldberg's Guide to Europe*. New York: The Vanguard Press, 1954.

Henle, Raymond. "Oral History Interview with Rube Goldberg." California. New York: Herbert Hoover Presidential Library Association, Inc., 1971.

Keller, Charles. *The Best of Rube Goldberg*. Englewood Cliffs, New Jersey: Prentice-Hall, Inc., 1979

Kinnaird, Clark, ed. *Rube Goldberg vs. the Machine Age: A Retrospective Exhibition of His Work with Memoirs and Annotations*. Exh. cat. New York: Hastings House, 1968.

Kramer, Hilton. "Laughter that is Close to Tears." *The New York Times*, January 16, 1977, p. 23.

Marzio, Peter C. *Rube Goldberg: His Life and Work*. New York: Harper & Row, 1973.

Marzio, Peter C., ed. *Do It the Hard Way: Rube Goldberg and Modern Times*. Exh. cat. Washington, D.C.: Smithsonian Institution, National Museum of History & Technology,1970.

Patton, Phil. "Rube Goldberg (Truman)." *Art News*, March 1977, pp.138–9.

Pearson, John F. "It's a Real Rube Goldberg." *Popular Mechanics*, November 4, 1933, pp. 66–67.

"Rube (A) to Rube (B)." *Newsweek*, May 4, 1964, p. 87.

Sabin, Roger. *Comics, Comix, and Graphic Novels: A History of Comic Art*. London: Phaidon, 1996. (See Sabin's book for an excellent survey and bibliography on comics as an artform.)

The Art of Invention: Rube Goldberg. Exh. cat. New York: Salander-O'Reilly Galleries, LLC, 1995.

Waugh, Coulton. *The Comics*. Jackson and London: University Press of Mississippi, 1991. (originally published, New York: MacMillan, 1947)

Wolfe, Maynard Frank. *Rube Goldberg: Inventions*, New York: Simon & Schuster, 2000. (See Wolfe's book for a complete bibliography of works by Rube Goldberg)

WEBSITE

Rube Goldberg Incorporated
www.rubegoldberg.com/

William Bergman

Born in Catskill, New York, 1969

Studied at The College of Saint Rose, Albany, New York (BS, 1993); New York State College of Ceramics, Alfred University, Alfred, New York (MFA, 1996)

Lives in Albany, New York

GROUP EXHIBITIONS

1999 *The Mohawk Hudson Regional*, The Harmanus Bleeker Library, Albany, New York

Motion and Design, G.E. Corporate Research and Development Center, Schenectady, New York

1998 *The Mohawk Hudson Regional*, Albany International Airport, Albany, New York

1997 *Beyond Built*, Rensselaer County Center for the Arts, Troy, New York

1995 *Layers of Darkness and Rain*, NYSCC, Alfred, New York

Iron and Light, BrewHouse, Pittsburgh, Pennsylvania

1993 *The Next Generation*, The Rice Gallery, Albany, New York

BIBLIOGRAPHY

Hanson, Peter. "A Man and His Machines." *Metroland*, August 2–8, 2001.

Jaeger, William. "Unsettling Contraptions." *The Albany Times Union*, October 15, 2000.

Steven Brower

Born in Washington D.C., 1969

Studied at Pratt Institute, Brooklyn, New York (BFA, 1991)

Lives in Brooklyn, New York

ONE-ARTIST EXHIBITIONS

2000 Taranaki, New Zealand

Art in General, New York

1999 *Utility*, Lombard-Fried Fine Arts, New York

Steven Brower, Secession, Vienna

1997 *Half Empty*, Lombard-Fried Fine Arts, New York

1996 *Downsize*, Lombard-Fried Fine Arts, New York

GROUP EXHIBITIONS

1999 *What Your Children Should Know About Conceptualism*, Neuer Aachener Kunstverein, Aachen and Brandenburgischer Kunstverein, Potsdam

Construction Drawings, Kunst-Werke Berlin

1998 *Some Young New Yorkers*, P.S.1, Long Island City, New York

1997 *Picturing: Art According to the World*, Center for Curatorial Studies, Annandale-on-Hudson, New York

BIBLIOGRAPHY

Carr, C. "Handyman's Special." *The Village Voice*, April 6, 1999.

Damianovic, Maia. *Steven Brower: Utility*. Exh. cat. New York: Lombard-Fried Fine Arts, 1999.

Steven Brower. Exh. cat. Vienna: Secession, 1999.

Diana Cooper

Born in Greenwich, Connecticut, 1964

Studied at Harvard College, Cambridge, Massachusetts (BA, 1986); New School Studio School (1990); Hunter College, New York (MFA, 1997)

Lives in Brooklyn, New York

ONE-ARTIST EXHIBITIONS

2001 Virginia Commonwealth University, Richmond

2000 Hales Gallery, London

1999 *The Best Part of the Song and It's Too Short*, Postmasters Gallery, New York

1998 Postmasters Gallery, New York

GROUP EXHIBITIONS

2001 *Personal Abstractions: Lee Bontecou, Gay Outlaw, Diana Cooper*, Sculpture Center, New York

2000 *Re-Drawing the Line*, Art in General, New York

Greater New York, P.S.1, Long Island City, New York

1999 *SHOUT OUTS*, Rice University Art Gallery, Houston

1998 *Exploiting the Abstract*, Feigen Contemporary, New York

USEFOOL, Postmasters Gallery, New York

BIBLIOGRAPHY

Crutchfield, Jean. *Diana Cooper*. Exh. cat. Richmond: Virginia Commonwealth University, 2001.

Davenport, Kim. *SHOUT OUTS*. Exh. cat. Houston: Rice University Art Gallery, 1999.

Schjeldahl, Peter. "Thanks for Painting." *The Village Voice*, March 17, 1998.

Roman de Salvo

Born in San Francisco, 1965

Studied at the California College of Arts and Crafts, Oakland (BFA, 1990); The University of California, San Diego, La Jolla (MFA, 1995)

Lives in San Diego

ONE-ARTIST EXHIBITIONS

2001 *Woods*, Quint Contemporary Art, La Jolla

2000 *Hearth Furnishings*, The Tahoe Gallery, Sierra Nevada College, Incline Village, Nevada

1999 *Recent Sculpture*, Quint Contemporary Art, La Jolla

1998 *Garden Guardians*, Museum of Contemporary Art San Diego, La Jolla

1997 *Cactus Arcade*, Founder's Gallery, University of San Diego, La Jolla

GROUP EXHIBITIONS

2002 *California Biennial*, Orange County Museum of Art, Newport Beach, California

2000 *Garden Project Giverny*, Museé d'Art Américain, Giverny, France

2000 Biennial, Whitney Museum of American Art, New York

1999 *Drip, Blow, Burn: Forces of Nature in Contemporary Art*, The Hudson River Museum, Yonkers, New York

1996 *Container 96—Art Across the Oceans*, Langelinie, Copenhagen, Denmark

1994 *inSite 94*, San Diego Natural History Museum, Balboa Park, San Diego

BIBLIOGRAPHY

Anderson, Maxwell et al. *2000 Biennial*. Exh. cat. New York: The Whitney Museum of American Art, 2000.

Yard, Sally. *Roman de Salvo: Fun Follows Function*. San Diego: Quint Contemporary Art, 2000.

Sam Easterson

Born in Hartford, Connecticut, 1972

Studied at the University of Minnesota, Minneapolis (MS, 1998); The Cooper Union for the Advancement of Science and Art, New York (BFA, 1994)

Lives in North Hollywood, California

ONE-ARTIST EXHIBITIONS

2002 *Animal, Vegetable, Video: Swamp Sanctuary*, RARE Gallery, New York

2000 *Animal, Vegetable, Video: Oasis*, RARE Gallery, New York

University of Virginia, Charlottesville

Transmitter, Vorarlberg, Austria

Art in General, New York

GROUP EXHIBITIONS

2001 *The World According to the Newest and Most Exact Observations: Mapping Art and Science*, Tang Teaching Museum, Skidmore College, Saratoga Springs, New York

2000 Centre d'Art Santa Mónica, Barcelona, Spain

1999 Hallwalls Contemporary Arts Center, Buffalo, New York

1998 *Dialogues: Sam Easterson and T.J. Wilcox*, Walker Art Center, Minneapolis, 1998.

Pandemonium, London Electronic Arts/ The Lux Centre, London

1997 *1997 Biennial*, Whitney Museum of American Art, New York

Station to Station, Artists Space, New York

BIBLIOGRAPHY

Fogle, Douglas. *Dialogues: Sam Easterson and T.J. Wilcox*. Exh. cat. Minneapolis: Walker Art Center, 1998.

O'Connor, Cara. *Sam Easterson*. Exh. cat. New York: Art in General, New York.

Peter Fischli and David Weiss

Peter Fischli

Born in Zurich, Switzerland, 1952; Studied at the Academia di Belle Arti, Urbino (1975–76); Academia di Belle Arti, Bologna (1976–77)

David Weiss

Born in Zurich, Switzerland, 1946; Studied at the Kunstgewerbeschule, Zurich (1963–64); Kunstgewerbeschule, Basel (1964–65)

Fischli and Weiss live in Zurich

ONE-ARTIST EXHIBITIONS

2002 Matthew Marks Gallery, New York

2001 Museu de Arte Contemporanea Fundacio de Serralves

2000 ARC Musee d'Art Moderne de la Ville de Paris, France

1996 *Peter Fischli and David Weiss: In A Restless World*, Walker Art Center, Minneapolis

Serpentine Gallery, London

1995 Kunsthaus Zurich

GROUP EXHIBITIONS

2000 *Learning Less*, Museo El Centro de la Imagen, Mexico

1998 11th Biennale of Sydney, Australia

1997 Skulptur Projekte, Munster, Germany

Documenta X, Kassel, Germany

1995 46th Venice Biennale, Venice, Italy

BIBLIOGRAPHY

Ammann, Jean-Christophe et al. *Peter Fischli/David Weiss: Room Under the Staircase*. Exh. cat. Frankfurt: Museum fur Moderne Kunst, and Stuttgart: Cantz, 1995.

Armstrong, Elizabeth et al. *Peter Fischli and David Weiss: In A Restless World*. Exh. cat. Minneapolis: Walker Art Center, 1996.

Parkett, no. 17, Zurich and New York, 1994.

Arthur Ganson

Born in Hartford, Connecticut, 1955

Studied at the University of New Hampshire, Durham (BFA,1978)

Lives in Somerville, Massachusetts

ONE-ARTIST EXHIBITIONS

2000 *Thoughtful Mechanisms: The Lyrical Engineering of Arthur Ganson*, Hood Museum of Art, Dartmouth College, Hanover, New Hampshire

Montgomery Museum of Fine Arts, Alabama

1999 *Gestural Engineering*, MIT Museum, Cambridge, Massachusetts (ongoing)

1998 *Machines*, Ricco Maresca Gallery, New York

1992 *Witty Machines*, Carpenter Center for the Arts, Harvard University, Cambridge, Massachusetts

GROUP EXHIBITIONS

1999 *ex machina*, Connecticut College, New London, Connecticut

Kabinett der Mechanik, Technorama, Winterthur, Switzerland

Innovations in Motion, The Discovery Museum, Bridgeport, Connecticut

1998 *Spinning Wheels and Whirling Wheels*, The Bruce Museum, Greenwich, Connecticut

BIBLIOGRAPHY

Ingalls, Zoë. "Fighting Physics to Engineer Sculptures." *The Chronicle of Higher Education*, February 6, 1998.

Sims, David. "You Can Almost Hear the Gears Turn Inside His Head." *Smithsonian*, January, 1996.

Tim Hawkinson

Born in San Francisco, 1960

Studied at the San Jose State University, San Jose, California (BFA, 1984); The University of California at Los Angeles (MFA, 1989)

Lives in Los Angeles

ONE-ARTIST EXHIBITIONS

2000 The Power Plant, Toronto, Canada

Uberorgan, MASS MoCA, North Adams, Massachusetts

1999 Ace Gallery, New York

Akira Ikeda Gallery, Taura, Japan

1997 *Secret Sync*, Ace Contemporary Exhibitions, Los Angeles

Southeast Center for Contemporary Art, North Carolina

1996 Yerba Buena Center for the Arts, San Francisco

The Contemporary Arts Center, Cincinnati

GROUP EXHIBITIONS

2002 *2002 Biennial*, Whitney Museum of American Art, New York

2001 *Celebrating Modern Art: The Anderson Collection*, San Francisco Museum of Modern Art, San Francisco

2000 *The Greenhouse Effect*, The Serpentine Gallery, London

1999 *48th Venice Biennale*, Venice, Italy

BIBLIOGRAPHY

Desmarais, Charles. *Humongulous: Sculpture and Other Works by Tim Hawkinson*. Exh. cat. Cincinnati: The Contemporary Arts Center, 1996.

Duncan, Michael. "Recycling the Self." *Art in America*, May 1997.

Monk, Philip et al. *Tim Hawkinson*. Exh. cat. Toronto: The Power Plant and North Adams: MASS MoCA, 2000.

Martin Kersels

Born in Los Angeles, 1960

Studied at the University of California, Los Angeles (BFA, 1984; MFA, 1995)

Lives in Los Angeles

ONE-ARTIST EXHIBITIONS

2001 ACME, Los Angeles

2000 Deitch Projects, New York

Kunsthalle Bern, Bern, Switzerland

1999 Dan Bernier Gallery, Los Angeles

1997 *Commotion: Martin Kersels*, Madison Art Center, Madison, Wisconsin

GROUP EXHIBITIONS

2000 *Made in California*, Los Angeles County Museum of Art

Departures: 11 Artists at the Getty, J. Paul Getty Museum, Los Angeles

1999 *Melbourne Biennial*, Melbourne, Australia

1998 *Young Americans 2*, Saatchi Gallery, London

1997 *1997 Biennial*, Whitney Museum of American Art, New York

1996 *Defining the Nineties: Consensus Making in New York, Miami, and Los Angeles*, Museum of Contemporary Art, Miami, Florida

BIBLIOGRAPHY

Duncan, Michael. "The Serious Slapstick of Martin Kersels." *Art In America*, April, 2001.

Kamps, Toby et al. *Commotion: Martin Kersels*. Exh. cat. Madison: Madison Art Center, 1997.

Lyons, Lisa. *Departures: 11 Artists at the Getty*. Exh. cat. Los Angeles: J. Paul Getty Trust, 2000.

Alan Rath

Born in Cincinnati, Ohio, 1959

Studied at Massachusetts Institute of Technology, Cambridge, Massachusetts (BS, 1982)

Lives in Oakland, California

ONE-ARTIST EXHIBITIONS

2001 *New Sculpture*, Haines Gallery, San Francisco

1999 *Friendly Machines*, Haines Gallery, San Francisco

1998 *Alan Rath: Robotics*, SITE Santa Fe, New Mexico

New Robotic Sculpture, Yerba Buena Center for the Arts, San Francisco

1996 Aspen Art Museum, Aspen, Colorado

1995 Contemporary Arts Museum, Houston, Texas

GROUP EXHIBITIONS

2001 *The Gravity of the Immaterial*, The Institute of Contemporary Art, Taipei, Taiwan

1999 *Ghost in the Shell*, Los Angeles County Museum of Art, Los Angeles

1998 *Body Mecanique*, Wexner Center for the Arts, Columbus, Ohio

BIBLIOGRAPHY

Boswell, Peter et al. *Alan Rath: Plants, Animals, People, Machines*. Santa Monica: Smart Art Press, 1995.

Grachos, Louis et al. *Alan Rath: Robotics*. Exh. cat. Santa Fe: SITE Santa Fe, and Santa Monica: Smart Art Press, 1999.

Jovi Schnell

Born in Arkansas, 1971

Studied at the The San Francisco Art Institute, San Francisco, California (BFA, 1992); De Ateliers 63, Amsterdam, Holland (1992–95); Skowhegan School of Painting and Sculpture, Skowhegan, Maine (1995)

Lives in Brooklyn, New York

ONE-ARTIST EXHIBITIONS

2002 *Galactic Pulses*, Derek Eller Gallery, New York

1999 Derek Eller Gallery, New York

1998 Arena Gallery, Brooklyn, New York

GROUP EXHIBITIONS

2001 *Ripe and Hazy*, Goliath Visual Space, Brooklyn

2000 *Landscape My Ass*, Vedanta Gallery, Chicago

1999 *SOMEWHEN*, Mass Art, Boston, Massachusetts

Art Lovers, Liverpool Biennial, England

1998 *...the revenge of L.H.O.O.Q.*, 450 Broadway Gallery, New York

USEFOOL, Postmasters Gallery, New York

BIBLIOGRAPHY

McCarthy, Gerard. "Jovi Schnell at Derek Eller Gallery." *Art in America*, March 1999.

Tung, Lisa. *SOMEWHEN*. Exh. cat. Boston: Massachusetts College of Art, 1999.

Jeanne Silverthorne

Born in Philadelphia, Pennslyvania, 1950

Studied at Temple University, Philadelphia, Pennslyvania (BA, 1971); Pennsylvania Academy of Fine Arts, Philadelphia, Pennslyvania (MA, 1974)

Lives in New York City

ONE-ARTIST EXHIBITIONS

2002 Shoshana Wayne Gallery, Santa Monica, California

2000 McKee Gallery, New York

1999 Whitney Museum of American Art at Philip Morris, New York

Galerie Nathalie Obadia, Paris

1998 Shoshana Wayne Gallery, Santa Monica, California

Wright Museum of Art, Beloit College, Wisconsin

1997 McKee Gallery, New York

1996 Institute of Contemporary Art, Philadelphia, Pennsylvania

GROUP EXHIBITIONS

1998 *Rubber*, Robert Miller Gallery, New York

1997 *Gothic*, Institute of Contemporary Art, Boston, travels to the Portland Art Museum, Oregon

Deep Storage, Haus der Kunst, Munich

1997 *Metamorphosis*, Galleria Claudia Gian Ferrari, Milan

BIBLIOGRAPHY

Singer, Debra. *Jeanne Silverthorne: The Studio Stripped Bare, Again*. Exh. cat. New York: Whitney Museum of American Art at Philip Morris, 1999.

Tannenbaum, Judith et al. *Jeanne Silverthorne*. Exh. cat. Philadelphia: University of Pennsylvania, 1996.

Wilson, Thomas H. *Jeanne Silverthorne: Towards A New Century*. Exh. cat. Beloit: The Wright Museum of Art at Beloit College, 1998.

Dean Snyder

Born in Philadelphia, Pennslyvania, 1953

Studied at Kansas City Art Institute, Kansas City, Missouri (BFA, 1975); Lanchester Polytechnic College of Art and Design, Coventry, England (1975–76); School of the Art Institute of Chicago, Chicago, Illinois (MFA, 1978)

Lives in Providence, Rhode Island

ONE-ARTIST EXHIBITIONS

1999 Instituto Cultural Peruano Norte Americano, Lima, Peru

1998 Jennjoy Gallery, San Francisco

1997 Miller/Block Gallery, Boston

1994 Zolla/Lieberman Gallery, Chicago

GROUP EXHIBITIONS

2001 *DeCordova Annual*, DeCordova Museum and Sculpture Park, Lincoln, Massachusetts

A Common Legacy: H.C. Westerman's Influences on Five Contemporary Sculptors, Vanderbilt University Fine Arts Gallery, Nashville, Tennessee

2000 *Formations*, Albany International Airport, Albany, New York

Showroom, Arts Center of the Capital Region, Troy, New York

BIBLIOGRAPHY

Baker, Kenneth. "Hint of the Grisly in Snyder's Sculpture." *San Francisco Chronicle*, June 18, 1998.

Boyce, Roger. "2001 DeCordova Annual Exhibition." *Art New England*, Oct/Nov. 2001.

McQuaid, Cate. "Tattoed Rawhide's Raw Energy," *The Boston Globe*, January 23, 1998.

ANIMAL FEEDER

QUARTET (A) SINGS SAD SONG,CAUSING MAN (B) TO
CRY INTO FLOWER POT (C).PAM TREE GROWS,SHAKING
COCOANUT (D) LOOSE,WHICH FALLS ON TURTLE(E).
TURT LE PULLS IN NECK,CAUSING STRING (F) TO LIFT
LAMPSHADE (G),EXPOSING MOUSE (H). CAT (I) LIFTS
BACK IN ANGER,CAUSING PITCHER (J) TO SPILL WATER
INTO FUNNEL (K),SHOWERING BATHER (L) WHO SCRUBES
HIMSELF,RELEASNG JACK*IN*THE*BOX (M).HITTINE
LEVER (N) WHICH CAU SES HAND (O) TO PRESS BUTTON (P)
WHICH STARTES FEEDING MACHINE (Q),LIFTINF COVER (R) AND
EXPOSING MEAL FOR RAVENOUS ANIMAL.

Rube Goldberg
Text for cartoon, ca. 1960
Type on paper
11 x 8.5 inches

CHECKLIST

ALL DIMENSIONS IN INCHES,
HEIGHT PRECEDES
WIDTH PRECEDES DEPTH

Rube Goldberg

All works by Reuben Lucius Goldberg (American, 1883–1970) given to the Williams College Museum of Art by George W. George, Class of 1941. Works are listed in order of accession number. As Rube Goldberg rarely dated his drawings, the following dates represent the approximate years in which they were drawn. Publication dates often differ as the finished cartoons were syndicated and reprinted in a variety of forms. Titles are taken from the first line of text in the cartoon when available.

Our special burglar alarm,
ca. 1960
Pencil on paper
8.5 x 11 inches
81.24.1

Special automatic exercise machine, ca. 1960
Pencil on paper
8.5 x 11 inches
81.24.2

How to keep bewhiskered uncle from kissing baby, ca. 1960
Pencil on paper
8.5 x 11 inches
81.24.3

How to recover hat that flies off, ca. 1960
Pencil on paper
8.5 x 11 inches
81.24.4

Artist makes himself a peanut butter sandwich, ca. 1960
Pencil on paper
8.5 x 11 inches
81.24.7

How to get junior away from television set, ca. 1960
Pencil on paper
8.5 x 11 inches
81.24.8

How to find keyhole in dark, ca. 1960
Pencil on paper
8.5 x 11 inches
81.24.9

Instant noodle cutter, ca. 1960
Pencil on paper
8.5 x 11 inches
81.24.10

Mouse dives at painting of piece of cheese, ca. 1960
Pencil on paper
8.5 x 11 inches
81.24.11

How to get damp salt out of salt seller, ca. 1960
Pencil on paper
8.5 x 11 inches
81.24.12

Sketch for cartoon,
ca. 1960
Pencil on paper
11 x 8.5 inches
81.24.13

Sketch for cartoon,
ca. 1960
Pencil on paper
11 x 8.5 inches
81.24.14

Running water installed in all trees in park to take care of housing shortage,
ca. 1960
Pencil and type on paper
11 x 8.5 inches
81.24.15

Quick-action gun to quiet guests, ca. 1960
Pencil and type on paper
11 x 8.5 inches
81.24.16

Simple one-shift bouncer,
ca. 1960
Pencil and type on paper
11 x 8.5 inches
81.24.17

Robut [sic] baby-sitter which plays gin rummy,
ca. 1960
Pencil and type on paper
11 x 8.5 inches
81.24.18

Armoured sitting room chair, ca. 1960
Pencil and type on paper
11 x 8.5 inches
81.24.19

Simple tube for administering smelling salts, ca. 1960
Pencil and type on paper
11 x 8.5 inches
81.24.20

Hand-propelled rackmobile for carrying home winnings from quiz programs,
ca. 1960
Pencil and type on paper
11 x 8.5 inches
81.24.21

Automatic dieting machine with goat attachment, ca. 1960
Pencil and type on paper
11 x 8.5 inches
81.24.22

Revolvometer for looking at modernistic art, ca. 1960
Pencil and type on paper
11 x 8.5 inches
81.24.23

Hydraulic walking beam, ca. 1960
Pencil and type on paper
11 x 8.5 inches
81.24.24

All-weather zipper for shrunken front door caused by use of green lumber in GI housing project,
ca. 1960
Pencil on paper
11 x 8.5 inches
81.24.25

Sketch for cartoon,
ca. 1960
Pencil on paper
11 x 8.5 inches
81.24.29

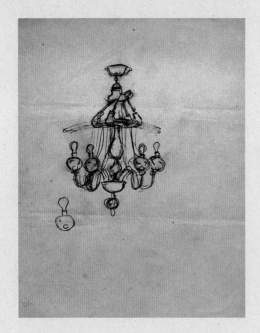

Rube Goldberg
Sketch for cartoon, ca. 1960
Pencil on paper
11 x 8.5 inches

*Study for simple
tube for administering
smelling salts*,
ca. 1960
Pencil on paper
11 x 8.5 inches
81.24.30

*Study for quick-action
gun to quiet guests
and robot babysitter*,
ca. 1960
Pencil on paper
11 x 8.5 inches
81.24.32

*Study for one-shift
bouncer*, ca. 1960
Pencil on paper
8.5 x 11 inches
81.24.33

*Study for robot
baby-sitter*, ca. 1960
Pencil on paper
11 x 8.5 inches
81.24.34

Sketch for cartoon,
ca. 1960
Pencil on paper
8.5 x 11 inches
81.24.35

*Study for automatic
dieting machine*,
ca. 1960
Pencil on paper
11 x 8.5 inches
81.24.36

*Study for revolvometer
and armoured sitting
room chair*, ca. 1960
Pencil on paper
11 x 8.5 inches
81.24.37

Sketch for cartoon,
ca. 1960
Pencil on paper
11 x 8.5 inches
81.24.38

*Study for hydraulic
walking beam and hand
propelled rackmobile*,
ca. 1960
Pencil on paper
11 x 8.5 inches
81.24.39

Sketch for cartoon,
ca. 1960
Ink on paper
7.25 x 10.5 inches
81.24.40

Text for cartoon, ca. 1960
Type on paper
11 x 8.5 inches
81.24.42

Text for cartoon, ca. 1960
Type on paper
11 x 8.5 inches
81.24.45

*Professor Butts is
operated on for fallen
arches*, ca. 1930
Pen and ink on card-
board
8.25 x 20.5 inches
81.24.49

*Professor Butts dives into
an empty swimming pool and
finds a simple idea for
dusting off the radio*, ca. 1960
Ink on paper
9 x 21 inches
81.24.50

*Professor Lucifer Gorgonzola
Butts invents a simple
way to feed your pet goldfish
when you're away on your
vacation*, 1933
Ink and pencil on paper
7.25 x 20.5 inches
81.24.51

*Professor Butts strolls
between two sets of gang-
sters having a machine
gun battle and is struck by
an idea for keeping a button-
hole flower fresh*,
ca. 1930
Pen and ink on cardboard
8 x 18.75 inches
81.24.52

*Professor Lucifer Gorgonzola
Butts A.K. invents simple self-
shining shoes*, ca. 1930
Pen and ink on cardboard
6.25 x 18.5 inches
81.24.53

*The Professor takes a swig of
goofy oil and invents a
self-sharpening razor blade*, ca.
1930
Pen and ink on cardboard
7.5 x 19.5 inches
81.24.57

*Professor Lucifer Gorgonzola
Butts A.K. invents a
self-emptying ashtray*, 1932
Ink and pencil on cardboard
6.25 x 20.5 inches
81.24.58

*Professor Butts evolves his latest
painless tooth-extractor in a state
of scientific delirium*, ca. 1930
Pen and ink on paper
7.5 x 19.5 inches
81.24.60

*Get one of our patent fans
and keep cool; Foolish
Questions—No. 2,222*, ca. 1925
Pen and ink
9 x 20 inches
81.24.61

*Professor Butts, taking his
morning exercise, kicks himself in
the nose and sees a simple
idea for cooling a plate of soup*,
ca, 1930
Pen and ink on cardboard
9 x 21 inches
81.24.62

*Now you know how to tie a
full-dress tie*, ca. 1918
Pen and ink on cardboard
8.5 x 13.5 inches
81.24.63

Sketch for cartoon, ca. 1960
Pencil on paper
11 x 8.5 inches
82.26.19

Sketch for cartoons, ca. 1960
Pencil on paper
8.5 x 11 inches
82.26.20

Sketch for cartoon, ca. 1960
Pencil on paper
11 x 8.5 inches
82.26.22

Sketch for a modern fountain,
ca. 1960
Pencil on paper
11 x 8.5 inches
82.26.26

Woman and eggbeater, ca. 1960
Pencil on paper
11 x 8.5 inches
82.26.29

Sketch for cartoon, ca. 1960
Pencil on paper
8.5 x 11 inches
82.26.82

Bill and Boob McNutt, ca. 1930
Pen and ink on cardboard
24 x 19 inches
83.29.25

Bill and Boob McNutt, 1932
Pen and ink on paper
24 x 19 inches
92.3.23

Bill and Boob McNutt, ca. 1930
Pen and ink on paper
24 x 19 inches
92.3.24

Tim Hawkinson
My Favorite Things, 1993
(detail of record drawing)
Gesso, wax, ink, shellac on
paper on board
46.5 inches diameter

CONTEMPORARY ART

William Bergman
Regret, 2001
Wood, steel, aluminum,
glass, plastic, lime-
stone, electronics,
and motors
Dimensions variable
Courtesy of the artist

Steven Brower
*Beyond Good and
Evil*, 2001
Mixed media
48 x 48 x 64 inches
Courtesy of the artist

Diana Cooper
The Big Red One,
1997
Mixed media on
canvas and wall
124 x 138 x 2 inches
Courtesy of the artist
and Postmasters
Gallery, New York

Roman de Salvo
Tissue Bank, 1998
Formica, MDF,
Corian, stainless steel,
aluminum, hardware,
tissue
57.5 x 13.5 x 23.5
inches
Courtesy of the artist
and Quint
Contemporary Art,
La Jolla, California

Sam Easterson
Video Maracas, 1999
Maracas, cameras,
flashlights, duct tape,
two-channel video
transferred to DVD
Dimensions variable
Courtesy of the artist and
RARE Gallery, New York

Fischli and Weiss
*Der Lauf der Dinge
(The Way Things Go)*,
1985–87
16mm film transferred
to DVD
30 minutes
Courtesy of the artists

*Flirtation, Love, Passion,
Hate, Separation*, 1986
Black and white
photograph
12 x 16 inches
On extended loan to The
Tang Teaching Museum
and Art Gallery at
Skidmore College from a
private collection

Arthur Ganson
Margot's Other Cat,
1999
Steel, motor, chair, cat
28 x 36 x 14 inches
Courtesy of the artist

Tim Hawkinson
My Favorite Things, 1993
Music box: roasting pan,
water bottle, plant
stand, scrounged bits of
metal, motorized
Nine record drawings:
gesso, wax, ink, shellac on
paper on board
Overall dimensions variable
(music box: 43 x 17 x 16
inches; record drawings:
46.5 inches diameter each)
Courtesy of the artist and
ACE Gallery, Los Angeles

Martin Kersels
*Attempt to Raise the
Temperature of a Container
of Water by Yelling at it*,
1995
7-gallon glass jar, 5 gallons
distilled water, underwater
speaker, digital recording
thermometer, amplifier,
CD player, compact disk,
plastic encased weight, high
density foam rubber,
wood, rubber, two tables
Overall dimensions variable
(large table with jar: 54 x
20 x 20 inches; small table
with thermometer: 32 x 15 x
15 inches)
Collection of Dillon Cohen,
New York

Alan Rath
I Want, 1988
Aluminum, acrylic, motor,
electronics, cathode ray tube
25 x 29 x 82 inches
Courtesy of the artist and
Haines Gallery, San Francisco

Jovi Schnell
Physical Plant, 2001
Acrylic, thread, and collage
on wall
Dimensions variable
Courtesy of the artist

Jeanne Silverthorne
*072101: The Scream (passing
through bile and butterflies,
encountering
alarms, gas, twinges, fluctuations
and surges)*, 2001
Rubber and PVC pipe
Dimensions variable
Courtesy of the artist and
McKee Gallery, New York

Dean Snyder
Tenigo, 2001
Animation and flipbook
Courtesy of the artist

Rube Goldberg
Sketch for cartoon, ca. 1960
pencil on paper
8.5 x 11 inches

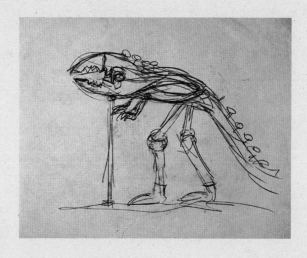

Rube Goldberg
Sketch for cartoon, ca. 1960
Pencil on paper
11 x 8.5 inches

Rube Goldberg's cartoon contraptions have delighted and inspired generations of readers and artists alike. I am grateful to the Williams College Museum of Art and The Tang Teaching Museum and Art Gallery at Skidmore College for their collaboration on this exciting project. The collaboration between these museums, both founded on the fusion of art and learning, is one that I hope will continue. *Chain Reaction* is the first exhibition in many years to present a large selection of works by this important and eccentric artist. It is a rare opportunity to work from an archive of such depth and diversity, and I would like to thank George W. George, son of Rube Goldberg, for making this material available through his substantial gift to the Williams College Museum of Art. This exhibition could not have been mounted without the support of the National Endowment for the Arts and the members and friends of both museums. Special thanks to Maynard Frank Wolfe, President of Rube Goldberg Incorporated, for his energy and support of this project from its inception.

I would like to thank the thirteen participating artists who engaged with Rube's work in ways that are multi-layered and complex. They were generous with their ideas and time, made new works for the exhibition, and patiently participated in a dialogue that opened doors to new ideas and connections. I am grateful for their engaging artwork and look forward to continued conversations. For their loans and assistance with the contemporary works in *Chain Reaction*, thanks to: Douglas Christmas, Alice Hutchinson, and Price Latimer, Ace Gallery, Los Angeles; Dillon Cohen, New York; Derek Eller, Derek Eller Gallery, New York; Lea Checcroni-Fried, Lombard-Fried, New York; Jay Gorney and Rodney Hill, Gorney, Bravin and Lee, New York; Kavi Gupta, Vedanta Gallery, Chicago; Cheryl Haines, Haines Gallery, San Francisco; Alexis Hubsman, RARE, New York; David McKee and Meg Larned, McKee Gallery, New York; Sina Najafi, *Cabinet* Magazine; Anna Quint, Quint Contemporary Art, San Diego; and Magdalena Sawon, Postmasters Gallery, New York.

At the Williams College Museum of Art thanks to: Michele Alice, John Anderson, Kenneth Blanchard, Melissa Cirone, Marion Goethals, Stefanie Spray Jandl, Robert Kove, Silvio J. Lamarre, Dorothy Lewis, Louise Mackey, Christine Mahar, Nancy Mathews, Beth Michaels, Ann Musser, Vivian Patterson, Judith Raab, Sean Riley, Barbara Robertson, Deborah Rothschild, Edith Schwartz, Greg Smith, William Steuer, Marilyn Superneau, Rachel Tassone, Amy Tatro, Amy Wood, and Theodore Wrona. Special thanks to Diane Hart, Registrar, and Hideyo Okamura, Chief Preparator, for helping bring together and build such a beautiful exhibition, and Lisa Dorin, Curatorial Assistant, who attended to every detail of this exhibition with savvy and calm. Thank you to student interns at Williams who helped during the initial stages of research for this exhibition: Alanna Gedgaudas, Nelli Gentle, Elyse Gonzales, and Kimberly Mims.

At the Tang Museum thanks to: Helaina Blume, Brian Caverly, Lori Geraghty, Ruth Greene-McNally, Allison Hunter, Susi Kerr, Gayle King, Chris Kobuskie, Jennifer O'Shea, Barbara Rhoades, and Barbara Schrade. Thanks to our installation crew: Tyler Auwarter, Liz Blum, Abraham Ferraro, Shaw Fici, Steve Martonis, Pearl Rucker, and Thaddeus Smith; and student interns, Daniel Byers and Ariel Magnes. Thanks to Skidmore professors and staff: Jay Rogoff, Lecturer in English; Barry Goldensohn, Professor of English; Peg Boyers, Barbara Melville, and Barry Pritzker.

Thanks to Barbara Glauber and Beverly Joel of Heavy Meta who designed this inventive catalogue with new photographs by Arthur Evans. Thank you to Lawrence Raab, Morris Professor of Rhetoric and Professor of English at Williams College and artist Dean Snyder for their poem and flip-book that make this publication a work of art itself.

Lastly, thanks to museum directors, Linda Shearer and Charles Stainback, for their continued encouragement and guidance. Their ongoing commitment to engaging critical ideas while supporting new artwork is a consistent inspiration. I dedicate this catalogue to Fiona and Georgia with hope that they too will discover the pleasures of the long way around a simple task.

Ian Berry
CURATOR

This catalogue accompanies
the exhibition

CHAINREACTION

RUBE GOLDBERG AND CONTEMPORARY ART

Williams College Museum of Art
July 21–December 16, 2001

The Tang Teaching Museum
and Art Gallery
at Skidmore College
January 26–April 14, 2002

This exhibition was organized
by the Williams College Museum
of Art, in collaboration with
The Tang Teaching Museum and
Art Gallery at Skidmore College
with support from The
National Endowment for the Arts.
Funding for the exhibition
at The Tang Museum was
provided by the Friends of Tang.

**Williams College
Museum of Art**
15 Lawrence Hall Drive, Suite 2
Williamstown, Massachusetts
01267

T 413 597 2429
F 413 458 9017
www.williams.edu/wcma

**The Tang Teaching Museum
and Art Gallery
at Skidmore College**
815 North Broadway
Saratoga Springs, New York
12866

T 518 580 8080
F 518 580 5069
www.skidmore.edu/tang

ISBN # 0-9708790-0-8

Library of Congress Control
Number: 2001095950

Available through
D.A.P./Distributed Art
Publishers
155 Sixth Avenue, 2nd Floor
New York, New York 10013
T 212 627 1999
F 212 627 9484

The Tang Teaching Museum
would like to thank the
artists, copyright holders and
rights holders of all images
in this exhibition for granting
permission to reproduce their
works in this publication.
Every effort has been made
to contact copyright holders
prior to publication.

Works by Rube Goldberg
are reproduced courtesy of
the Williams College
Museum of Art and Rube
Goldberg, Inc. Rube Goldberg
is a registered trademark
of Rube Goldberg, Inc.

FRONT COVER AND
PAGES 1, 3, 4 & 5:
Rube Goldberg
*The Professor takes a
swig of goofy oil and
invents a self-sharpening
razor blade, ca. 1930
(detail)*

BACK COVER:
Jeanne Silverthorne
Untitled photograph,
1999 (detail)

Photographs by
Arthur Evans and
Oren Slor

Designed by Barbara
Glauber and Beverly Joel/
Heavy Meta

Printed in Germany by
Cantz